D1258069

THE
KNITTER'S DICTIONARY

KNITTING KNOW-HOW FROM **A** TO **Z**

The Knitter's Dictionary. Copyright © 2018 by Kate Atherley. Manufactured in China. All rights reserved. No part of this book may be reproduced in any form or by any electronic or mechanical means including information storage and retrieval systems without permission in writing from the publisher, except by a reviewer who may quote brief passages in a review. Published by Interweave Books, an imprint of F+W Media, Inc., 10151 Carver Road, Suite 300, Blue Ash, Ohio 45242. (800) 289-0963. First Edition.

www.fwcommunity.com

Interweave®

www.interweave.com

22 21 20 19 18 5 4 3 2 1

SRN: 18NK02
ISBN-13: 978-1-63250-638-2

EDITORIAL DIRECTOR:
Kerry Bogert

CONTENT EDITORS:
Maya Elson & Kerry Bogert

TECHNICAL READER/COPYEDITOR:
Lisa Silverman

ART DIRECTOR:
Ashlee Wadeson

COVER & INTERIOR DESIGNERS:
Ashlee Wadeson & Julie Levesque

ILLUSTRATOR:
Julie Levesque

CONTENTS

1

INTRODUCTION

I first learned to knit when I was a young girl, at my grandmother Hilda's knee. I was a very confident maker of doll blankets and scarves at an early age. Spurred on by her clear instruction, my ability to form perfect stitches and manage yarn and needles was firmly formed.

When I picked up the needles again, as a teenager, I had moved far away from her. So I found myself a pattern for something that looked easy to knit, chose a ridiculous brightly colored yarn, and sat down, keen to start working.

But I was utterly lost. I was fine with the needles and yarn, but I couldn't make any sense of the instructions. Handling the needles and yarn was an entirely different skill than reading the patterns. Although my grandmother had made sure I was a master at the first, we had never gotten around to the second topic in our lessons: the language, rules, and codes embedded in knitting patterns.

There are many books, magazines, online tutorials, and store classes that show you the mechanics of knitting, but very few that address how to read the instructions. That's what this book is all about.

Knitting has its own language: technical terms, funny abbreviations, and familiar words used in very particular ways—"repeat," "even," "right side," etc. Knitting patterns are like little computer programs, with their own rules and notations.

This book is a guide to help you understand that language and patterns. If you're able to read the instructions, you'll be able to successfully knit them.

We've organized items alphabetically, and it's squarely between a dictionary and an encyclopedia. As you're working through a project, you've got a quick way to look up a term you're not familiar with. Some sections are larger, providing not only guidance on the

individual words, but on the larger context to expand your knitting knowledge.

Wonder why designers are always going on about gauge? Want to know more about the differences between a raglan and a set-in sleeve sweater, and why it matters when you're choosing a pattern? And what is "heavy worsted," exactly? This book aims to answer all those questions and more, to help you break the code, and be a more powerful and successful knitter. It's one I think you'll want to keep in your knitting bag, always.

GETTING STARTED WITH PATTERNS

Before you pick up your needles and start knitting, it's a good idea to take a moment to familiarize yourself with your pattern and gather all the tools and materials you need.

SET-UP FOR SUCCESS

Before you start working on a pattern, make sure you have the most recent version. If you downloaded it from a website, check for updates. If you're working from a book or magazine pattern, do a quick web search to see if the publisher has posted any corrections (aka *errata*; see p. 41).

If you're working from a digital pattern, make a backup copy; if you're working from a paper pattern or book, print or photocopy the pattern (when permitted under the publisher's copyright statement) and store the original somewhere safe. Put your working copy in a plastic sheet protector to protect it from coffee spills.

If working from paper, keep some scrap and a pencil handy for taking notes and tuck the notes inside the sheet protector. If you are working from a digital pattern, make sure you keep your notes as a separate file or as annotations to the pattern file.

If it's a multisize pattern, go through and highlight the numbers for the size you're working throughout the instructions. At the same time, scan the pattern for things you might want to know before you begin. In particular, look for the phrases "*at the same time*" (see p. 15) and "*reversing shaping*" (see p. 90), as these need some advance planning.

Many patterns offer explanations of terms, abbreviations, and special techniques. It's important to familiarize yourself with those. Keep your *Knitter's Dictionary* handy for anything that might not be explained.

TOOLS

Review the materials, needles, and notions list for the project: put them all in one place so they're ready when you need them. Make sure to include stitch markers, a tape measure, scissors, and a yarn needle (see *notions*; p. 81); these sometimes aren't included on the list, but you'll probably need them.

I also like to make sure that I have some safety pins, a crochet hook for picking up dropped stitches, stitch holders and/or scrap yarn I can use as a stitch holder, a ruler, and a needle gauge on hand as well.

Keep the extra skeins of yarn you're not actively using in a plastic ziplock-style bag, away from moths, dust, and inquisitive pets and children. Keep the receipt, and if you're working from skeins that need to be wound before use, don't wind all of them. If you don't use them all, you may well be able to return or exchange. To that end, it's good to know what your store return policies are when buying yarn. And if they won't take back the leftover skein or two, you can always use them for something else . . . hats and mittens don't require much yarn!

SIZE AND FINISHED MEASUREMENTS

Many knitted items have multiple sizes—socks, mittens, hats, garments. For these, you'll need to decide which size you want to make.

Not all knitting patterns present sizing information in the same way. However, you should be able to find some semblance of the following in any pattern: indicator of sizes, finished measurements, and a schematic. The most helpful patterns will also provide

some kind of fit or sizing recommendation. See *ease* (p. 39) for more information on how to choose what size to make.

size

A pattern may or may not list a "size." This is sometimes labelled as "to fit." It's essentially what you'd see written on the label inside commercially made clothes: simply a rough indicator of the relative bigness or smallness of the piece. It provides a guide to who the pattern is for, but it should be very much a secondary consideration when deciding which size to make. For more information on how to choose a size, see *size* (p. 98).

finished measurements

Names vary, but this section tells you the dimensions of the actual pieces as knitted (once blocked). These are what you'd get if you put the knitted item on a flat surface and took a tape measure to it. See *finished measurements* (p. 47) for more information.

GAUGE

A pattern should list a gauge, which is a measurement of how many stitches and rows you should achieve over a certain distance (usually per inch [2.5 cm]). This information does two things: it helps you choose yarn and helps you identify which size needles to use. Ultimately, the purpose of gauge is to help you make sure that the piece you knit comes out to be the correct size! See *gauge* (p. 51) for more information.

YARN

All patterns should recommend a yarn and tell you the yarn used in the sample shown.

See *fiber care* (p. 45) for more information on the properties of commonly recommended yarns.

yarn substitution

You might want to work the project with the yarn specified in the pattern, but you don't have to. After all, it might not be available in your area, or it could well have been discontinued.

If you choose not to use the yarn specifically listed in the pattern, find something as close to it as you can in fiber mix, coloring, and texture. Doing so will help you achieve results similar to what you see in the pictures. In general, a project with lots of texture looks better knit with a smooth yarn in solid or nearly solid colors; plainer patterns suit busier colors and more textured yarns. For more information, see *yarn attributes, color* (p. 117), *yarn attributes, textures* (p. 118), and *yarn attributes, weights* (p. 119).

HOW MUCH TO BUY

Always buy yarn by length, not weight or number of balls. Weight can differ greatly by fiber (for example, cotton is much heavier than wool), and ball/skein size varies by brand, so neither of these is a reliable guideline when substituting yarn.

understanding yarn labels

While yarn labels (sometimes called ball bands) can differ from company to company, there is key information all labels typically contain. Fiber content, washing instructions, skein yardage, dyelot, color name, and suggested gauge are the most common and vital details to look for when reading the label.

For more information on label graphics, see *fiber care symbols* (p. 46).

SUPERWASH MERINO DK

Fern Heather

Fiber Company

Fiber Company

100% Superwash Merino Wool — fiber content

yardage —
Yardage
221 yds / 202 m

weight —
Weight
3.5 oz / 100 g

3 LIGHT — yarn-weight symbol

Machine wash cold gentle.
Hand wash normal.
Do not wring. Dry flat. — washing and care information

— washing symbols

needle and knitting gauge information —
US6 / 4mm
20 st = 4" (10cm)

H / 5mm
3.5 - 4 sc / inch — hook and crochet gauge information

Made in Peru — manufacturing details

yarn color —
COLOR
13-102

DYE LOT
19-0 — dyelot

RN 148629

YARN RECOMMENDATIONS
For Specific Techniques and Projects

PROJECT TYPE	NEED	LOOK FOR
COLORWORK	A yarn with give for blocking, but that will hold its shape over time.	Wool (regular or superwash), other animal fibers.
LACE	A yarn with give for blocking.	Wool (regular or superwash), other animal fibers, silk.
CABLES	A yarn with give for blocking that will hold its shape over time.	Wool (regular or superwash), other animal fibers.
WINTER ACCESSORIES	A yarn that insulates, provides warmth, wicks away moisture, doesn't freeze.	Wool (regular or superwash), other animal fibers, silk.
SUMMER WEAR	A yarn that breathes.	Linen, cotton, hemp, light wools.
BAGS	Strong yarn.	Wool (regular; felted), hemp.
SEAMLESS GARMENTS	A light yarn that doesn't stretch too much.	Wool (not superwash), wool and man-made blends.
CHILDREN'S WEAR	A warm, breathable, machine-washable yarn.	Wool (superwash), wool/cotton or wool/acrylic blends. Avoid 100% man-made fibers.
DOG SWEATERS	A warm, breathable, machine-washable yarn.	Wool (regular or superwash), other animal fibers.
SOCKS	A washable, breathable, strong yarn blend with elasticity either innate in the fibers or through the addition of elastic.	Wool (superwash)/nylon blends, wool/silk blends, cotton or bamboo blends with added elastic.

3

A–Z OF KNITTING

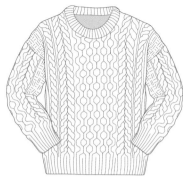

Fig. A1 Aran sweater

ACROSS THE ROW/RND

This phrase is as simple as it sounds. You work in the established pattern to the end of the row or round.

ACRYLIC (FIBER/YARN)

An oil-based polymer used to make yarn. It's colorfast and very stable in that it doesn't shrink, stretch, or fade. However, it is not good for winter wear, since acrylic fabrics can absorb water and freeze. It also doesn't have the give required for blocking, so it is not suitable for lace or colorwork. See also *fiber care*.

ACTUAL

Most often in patterns in the context of measurements. A pattern might list "actual" measurements with the sizing information, referring to the measurements of the finished knitted piece(s)—as opposed to a body-size measurement. "Finished measurements" is sometimes used in the same way. See also *ease; measurements, body; measurements, finished.*

ALPACA (FIBER/YARN)

From the coat of an alpaca, this fiber is warmer than sheep's wool and very soft. It tends to shed and pill and is relatively heavy. Best used for smaller pieces or garments with seams. It's excellent blended with sheep's wool. See also *fiber care*.

ALT

Alternate. Every other.

ANGORA (FIBER/YARN)

Derived from the coat of Angora rabbits, this fiber is very soft and warm, though it tends to shed and pill. Works best blended with other fibers; it adds warmth and a halo of fuzziness. Angora allergies are common. See also *fiber care*.

APPROX

Approximately or approximate.

ARAN (SWEATER)

A heavily cabled sweater, associated with Ireland. (Fig. A1)

ARAN (YARN)

See *yarn attributes, weights.*

ARMHOLE, ARMSCYE

The section of a garment body where the sleeve is attached.

AS EST, AS ESTABLISHED, AS SET

Used when continuing a previously established pattern, most often after increases or decreases, or some other special instructions, to tell you to go back to what you were doing before.

EXAMPLE

Row 1: (K1, p2) across the row.

Row 2: (K2, p1) across the row.

Continue as established until 2" (5 cm) from cast-on edge.

"As established" here indicates that you should keep working ribbing.

AS IF TO KNIT, AS IF TO PURL

Usually refers to slipping stitches, e.g., slip as if to knit, or transferring stitches to another needle. When working "as if to knit" the needle is put through the next stitch on the left needle from front to back coming in from the left, the same as when working a knit stitch. See also *sl, slip.*

ASTERISK *

Often used in pattern instructions as part of a repeat, typically to indicate the start of an instruction that is to be repeated. See also *repeat.*

AT THE SAME TIME

Indicates that two sets of instructions need to be worked simultaneously. When you see this phrase, read ahead to make sure you identify the two different instructions and the "trigger point."

EXAMPLE

Left Front Armhole Shaping

Row 1: (RS) K1, ssk, k to end.

Row 2: (WS) Purl.

Repeat the last 2 rows 6 times. AT THE SAME TIME, when the armhole measures 1" (2.5 cm), start the neckline shaping, as follows:

Next row, neckline shaping: (RS) Work in pattern as set to the last 3 sts, k2tog, k1.

Work the neckline shaping row 15 times. When the armhole shaping is complete, work even at the start of the RS rows.

The first instruction is the armhole shaping (the decrease at the start of the row). The second instruction is the neckline shaping (the decrease at the end of the row). "At the same time" alerts you that you'll need to watch for the point when you have to start the neckline shaping. In this case, it's when the armhole measures 1" (2.5 cm). This means that the armhole decrease won't yet be completed when you hit that distance.

As soon as you hit that point, you'll keep going with the armhole decrease at the start of the row but then also start working the neckline decrease at the end of the row. The key is to keep track of the two things separately: keep count of your armhole decreases, 1 to 6, and keep count of your neckline decreases, 1 to 15.

AYO

Afterthought Yarnover.

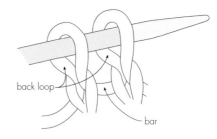

Fig. B1 back loop and bar

BABY (YARN)

See *yarn weights*.

BACK LOOP

Refers to the back of a stitch on the needle; a conventional Western-style knit stitch is mounted on the needle with the right leg positioned at the front and the left leg at the back. (Fig. B1) See also *ktbl; tbl*.

BACKWARD KNITTING

Can mean 1) undoing a completed row, sometimes referred to as "tinking" ("tink" is "knit" spelled backward), or 2) working a knit stitch from left to right across a row or round to avoid purling.

BACKWARD-LOOP CAST-ON

Also known as the e-wrap, this is a method to create new stitches that can be used for increasing and casting on. This is a good neutral increase, as it doesn't have a particular lean, and it adapts nicely to be a knit or purl. See also *cast-on; increase*.

TECHNIQUE

*Loop working yarn as shown and place it on needle backward (with right leg of loop in back of needle). Repeat from *. (Fig. B2)

BALL

One type of put-up for yarn: a ball shape. Usually wound for the end to be pulled from the center or the outside—knitter's choice. See also *center-pull ball; put-up*.

BALL WINDER

A tool to wind yarn into a ball, often used in conjunction with a swift or to rewind untidy balls of yarn or undo larger pieces of knit fabric. (Fig. B3) See also *swift*.

BAMBOO (YARN/FIBER)

A highly processed fiber derived from the bamboo plant. It is shiny like silk and has antibacterial properties. It can stretch out over time and is best for smaller pieces or garments with sleeves. Works well blended with other more stable fibers. See also *fiber care*.

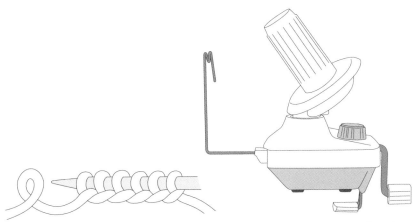

Fig. B2 backward-loop cast-on **Fig. B3** ball winder

BAR

The strand of yarn running between stitches, most easily seen when looking at the row below the stitches separated by the left and right needles. (Fig. B1)

BAR INCREASE

Another name for the kfb increase. See also *increase.*

BATWING

See *sweater types.*

BC

Usually short for "background color" in a colorwork pattern. Sometimes used as shorthand for "back cross" in a cable pattern. See also *cables; colorwork.*

BEANIE

See *hat styles.*

BEG

Begin, begins, beginning.

BEING CAREFUL NOT TO TWIST

When joining for knitting in the round, this is a reminder that cast-on stitches should not be allowed to twist before being joined. This instruction isn't always listed, but it's implied. If a pattern requires you to make a twist, to create a Möbius, it will always say so. See also *circular knitting.*

BERET

See *hat styles.*

BET

Between.

BIND-OFF

Also known as "cast-off," this is the act of creating a finished edge when you have completed the knitting.

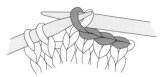

Fig. B4 standard knitted bind-off

standard knitted bind-off

This is the most common method for binding off. It is not very stretchy; if it's too tight you can use a needle one to two sizes larger to work the stitches. Use this method for edges that will be sewn into seams or finished in some way (such as stitches being picked up and knitted).

TECHNIQUE

Slip 1 stitch, *knit 1 stitch, insert left needle tip into first stitch on right needle, pass this stitch over the second stitch, and off the needle—1 stitch remains on right needle and 1 stitch has been bound off. Repeat from * until all stitches have been worked. Cut the yarn and pull through final stitch to secure. (Fig. B4)

If it's a knit/purl pattern stitch, such as ribbing, knit the knits and purl the purls as you work across the row.

other bind-offs

There are many other bind-off methods. For other popular methods covered in this book, see also: *Jeny's surprisingly stretchy bind-off, lace bind-off, sewn bind-off, three-needle bind-off.*

DID YOU KNOW?

You need about four times the length of the row in yarn to work a bind-off—more if it's a particularly stretchy method.

BLOCKING

"Blocking" is a catch-all term for manipulating your finished knitting to smooth out the fabric, even out the stitches, tidy up the stitch patterns, and bring the fabric to finished size. (Fig. B5) Blocking should always be done before you sew together pieces and finish. There are several methods for doing this, and which you should use varies with the project in question.

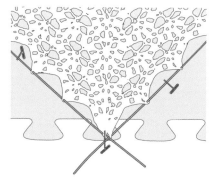

Fig. B5 lace design being blocked on mats, with T-pins and blocking wires

BLOCKING METHODS

PROJECT / FABRIC	BLOCKING METHOD
SCARF OR SHAWL non-lacy	Wash according to yarn-washing instructions, lay flat to dry.
SCARF OR SHAWL lacy	Soak, roll in towel or machine spin, stretch and pin to dry using mats, wires, and pins.
GARMENT plain or simple textures, cables	Wash according to yarn-washing instructions, lay flat to dry. Don't pin or stretch unless you need to for sizing. If you do stretch to size, you will need to do it every time you wash the piece.
GARMENT lace, stranded colorwork	Wash according to yarn-washing instructions, lay flat to dry; steam if required for final smooth. Don't pin or stretch unless you need to for sizing. If you do stretch to size, you will need to do it every time you wash the piece.
ACCESSORY plain or cabled: mitten, hat, sock, etc.	Wash according to yarn-washing instructions, hang to dry. Sock and mitten blockers not required unless you want to stretch the item for photography.
ACCESSORY stranded colorwork	Wash according to yarn-washing instructions, stretch slightly to dry; steam if required for final smooth.
BLANKET non-lacy	Wash according to yarn-washing instructions, lay flat or gentle machine dry in a bag.

BLOCKING TOOLS

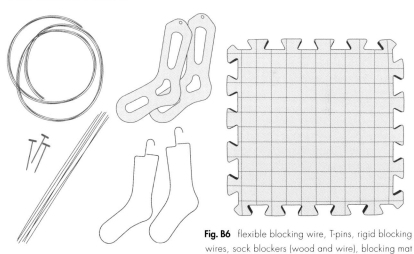

Fig. B6 flexible blocking wire, T-pins, rigid blocking wires, sock blockers (wood and wire), blocking mat

BO

Bind-off. See *bind-off*.

BOAT NECK

See *necklines and collars*.

BOBBINS

For holding small lengths of yarn; specifically for working intarsia colorwork. See also *intarsia*.

BOBBLE

Also known as a popcorn or knot, a bobble is a raised "bump" of stitches worked out of one stitch, used to create textural effects.

The simplest way to create a bobble is to work multiple times into a single stitch—often alternating knits and purls or knits and yarnovers. A few rows are worked on this group of stitches and then they are decreased back down to one stitch again before continuing with the row. All sorts of variations exist: varying the number of stitches and rows, using different increase and decrease methods. (Fig. B7) See also *nupp*.

Fig. B7 bobbles

BONNET

See *hat styles*.

BOOMERANG HEEL

See *short-row heel*.

BOR

Beginning of row/round.

BOTTOM UP

When working a sweater pattern from the hem to the neckline it is worked "bottom up." See also *sweater construction*.

BOUCLÉ (YARN)

See *yarn attributes, textures*.

BRACKETS [], PARENTHESES ()

Used in pattern instructions to separate numbers for different sizes or repeats. When a pattern is written for multiple sizes, and there are different instructions or numbers needed, brackets or parentheses are used to divide up the instructions for the different sizes.

EXAMPLE

If a pattern has three sizes, each with a different number of stitches to be cast on, parentheses will separate the sizes this way:

Cast on 90 (100, 110) stitches.

Oftentimes brackets are used to indicate a stitch combination that is repeated. It will appear this way:

EXAMPLE

Row 1: K3, [p1,k3] to the last st, p1.

BRIOCHE

A highly textured fabric, most often based around a (k1, p1) ribbing pattern. It can be made with one or two colors. It can be worked in two different ways. No matter which method you use, the basic steps are the same: every other stitch is worked as a doubled stitch, and the alternate stitches are slipped.

knit below method

Doubled stitches are created by working (knitting or purling as the pattern requires) into the loop of the stitch below the one on the needle. On each row, every other stitch is worked as a doubled stitch, and the alternate stitches are worked normally. A classic full brioche fabric works all stitches in this manner, alternating the worked and the doubled stitches on alternate rows.

slip-yarnover method

Each row or round is worked in two passes, alternating stitches. Half the stitches are worked normally, the other half are set up as doubled stitches, by slipping them and wrapping a yarnover around the needle. On following rows, the stitch and yarnover are worked together as one. If they are knit together, it's referred to as a brioche knit, brk; if they are purled together, this is known as a brioche purl (brp).

Fisherman's rib is a variant, where every other stitch is worked brioche-style, the alternate stitches worked plain. It's commonly worked with the knit-below method, with the doubled stitches created every other row.

The fabric lies flat, making it good for pieces like scarves and blankets. See also *brk; brp; fisherman's rib.*

BRK

Brioche knit. In a brioche pattern, this means to knit the stitch together with the yarnover that accompanies it.

BRP

Brioche purl. In a brioche pattern, this means to purl the stitch together with the yarnover that accompanies it.

BRUSHED (YARN)

See *yarn attributes, textures.*

BULKY (YARN)

See *yarn attributes, weights.*

BUTTONHOLE

A hole through which a button can be pulled, created either with yarnovers or by binding off a small number of stitches.

TECHNIQUE

Classic yarnover buttonhole
Work (yo, k2tog). If you're working a ribbing pattern, you can vary the decrease so as not to disturb the ribbing, e.g., p2tog, ssk.

Classic 2-row buttonhole
On the first row, bind off 2 or 3 stitches. On the following row, work a kfb, then use the cable cast-on method to restore the remaining 1 or 2 stitches.

C2R, C2L, C2F, C2B, C1/1R, C1/1L

Abbreviations of this format are for cable turns. You should always consult the pattern you're working for specific instructions, since usage and process can vary. See also *cables*.

CABLES

A twist created by knitting stitches out of order. Thousands of variations are possible, with different numbers of stitches, combinations of knit and purl stitches, and different placement. (Fig. C1)

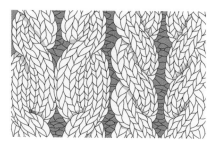

Fig. C1 cables

cable names

The names of cable turns vary between designers and publishers. Though there are some standard forms, usage is not consistent.

Although cable names are supposed to suggest how the cable is worked and help you remember what to do, you are not expected to know what these names mean in any given pattern. Always look for a glossary or abbreviations list to ensure you know what the designer intended.

EXAMPLES

C4R (Cable 4 stitches to the right): This indicates the total number of stitches over which the cable is worked and the direction it turns.

C4B (Cable 4 stitches to the back): This means the same thing as C4R, but indicates where to hold the cable needle with the resting stitches (B=back) instead of the direction of the turn.

C4/2R (Cable 4 stitches over 2 stitches to the right): This gives the total number of stitches

CABLE TIP

Stitches should always be slipped to and from a cable needle purlwise to avoid twisting or reorienting them.

Fig. C2 cable needles

in the cable followed by the number of stitches worked in the first step and the direction of the twist.

RT (right twist); LT (left twist): These are usually used for 2-stitch cables.

FC; BC; RC; LC: In these, C=crosses—front, back, right, and left.

RPC; LPC: These are also crosses with an added P for "purl" to indicate that some of the stitches are purled. Sometimes when purls are involved you'll see a T (for "turn") instead of a C, because some designers consider these "twists" rather than cables.

cable needle

A tool that holds stitches temporarily while working cables. A purpose-made cable needle isn't absolutely needed. You can also use a short dpn, a bobby pin, or any number of other things for the same purpose, as long as the stitches fit onto it. When working with a cable needle, slip stitches from the left needle to the cable needle and move to either the front or back of the work as the cable calls for. Work the required stitches on the left needle, then return the stitches on the cable needle to the left needle and continue knitting in pattern. (Fig. C2)

cabling without a cable needle

Rearranging the stitches on the left needle before you knit them to cross a cable, instead of using a cable needle. There are several ways to do this; the following example is one method for one type of cable turn.

EXAMPLE

C4B: Insert the tip of the right needle purlwise into the fronts of the third and fourth stitches on the left needle. Pull the left needle out of the first 4 stitches. The first 2 will fall loose; let the third and fourth slip to the right needle. Use the tip of the left needle to catch the live stitches, coming in behind the work. Return the third and fourth stitches from the right needle back to the left without twisting them. Knit across the stitches.

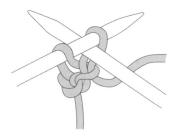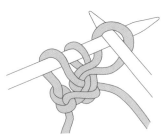

CABLE CAST-ON

A simple variation of the knitted method that makes an attractive and even edge that's good for seaming and picking up stitches.

TECHNIQUE

If there are no established stitches, begin with a slipknot placed on the needle in your left hand. As if you're knitting, put the tip of the right needle into stitch, wrap the yarn around, bring it through; leaving the previous stitch on the left needle, pull the new loop out a little and place it on the left needle. *Insert the right needle between the first 2 stitches on left needle. wrap the yarn around, bring it through; leaving the previous stitch on the left needle, pull the new loop out a little and place it on the left needle. Repeat from *. (Fig. C3)

To make this easier, leave some slack when you place the new stitch on the left needle. Place the right needle in between the two stitches and then tug on the yarn to snug it up. This ensures the stitches are perfectly, evenly spaced.

CAMEL (FIBER/YARN)

Fiber derived from the two-humped Bactrian camel. Warm and soft, this fiber resists felting and is quite expensive. Best used to knit smaller pieces or garments with seams. Excellent blended with sheep's wool. See also *fiber care*.

CAST-ON

To create loops on your needle to start a knitted fabric. The cast-on row is not counted as a row and is referred to as the cast-on edge. There are numerous methods for doing this; this book covers a variety of the most well-known and useful methods.

Note: For more on the cast-ons listed here, look for them alphabetically by the first letter within the A–Z section.

TYPE OF CAST-ON NEEDED	RECOMMENDED CAST-ON
versatile, beginner friendly	backward-loop, cable
versatile, stretchy	long-tail
a temporary edge that allows you to create live stitches for knitting in opposite direction later	provisional
adds stitches to working knitting	backward-loop, knitted, cable

TIPS FOR KNITTING WITH CENTER-PULL BALLS

- Only pull from the center on a ball that is well-wound. A ball loosely or roughly wound is more prone to tangling as you work, and you risk yarn barf.

- Never pull from the center of a ball of silk, bamboo, or other very soft or drapey yarn, as they will collapse on themselves and tangle as you work with them.

- Don't pull from the center of a donut-shaped ball, either—they aren't wound for it.

- If you pull from the outside, it's a good idea to keep the ball of yarn in a bowl or bag to contain it and protect it as it rolls around.

CAST-ON TAIL
The short length of yarn that remains unworked at the beginning of a cast-on edge. For ease of weaving in, it should be at least 3–4" (7.5–10 cm) long.

CASHMERE (FIBER/YARN)
Derived from the coat of Cashmere goats. This fiber is very warm and soft, though it tends to pill. Quality varies widely, so be prepared to pay top dollar for the best. Best for accessories that don't suffer much friction, such as hats. See also *fiber care*.

CAST-OFF
Another term for bind-off, common in the United Kingdom and Canada. See also *bind-off*.

CC
Contrast color. See also *colorwork*.

CDD
Centered double decrease. See *increases*.

CENTER-PULL BALL
A ball of yarn wound specifically to enable the knitter to be able to pull the strand that's on the inside. The ball will ravel from the inside out and retain its basic shape. Many knitters prefer pulling the yarn from the center, as the ball sits still while you're working. Yarn barf is a risk. See also *yarn barf*.

CHAINETTE
See *yarn attributes, textures*.

CHARTS

A visual way to represent stitch pattern instructions on a graph. Often used for lace, cable, and colorwork patterns. Any written instructions can be represented in a chart, and any chart can be written out as instructions. Which you use is a matter of preference and learning style: visual learners or those who are good at pattern recognition tend to prefer charts; auditory learners tend to prefer written instructions. One isn't better or more proper than the other.

There is some standardization in charting, but symbols and their uses can differ in patterns from different countries and publishers. You should always consult the key before you begin to be clear on all symbols and their meanings.

EXAMPLE

- Worked over 15 stitches and 6 rows.
- The chart is worked flat in rows. You know this because of two things: the row numbers alternate sides of the chart, and there are both right side (RS) and wrong side (WS) definitions for the blank and dot symbols.

SAMPLE CHART 1

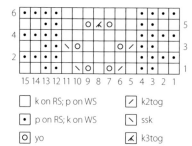

k on RS; p on WS

p on RS; k on WS

yo

k2tog

ssk

k3tog

The row numbers indicate which direction to read (row 1, stitch 1 is at the bottom right-hand corner); here you read row 1 from right to left, but row 2 left to right. Although this may seem odd, it actually matches the direction you knit. In the first row, you work the stitches in order: 1, 2, 3, . . . 13, 14, 15. When you turn around to come back, the first stitch worked is the last from the previous row, so it's 15, 14, 13, . . . 3, 2, 1.

Most charts start with a RS row, but not all. It's important to check the position of the row numbers to make sure you're working in the correct direction.

Symbols also change meaning between the RS and the WS rows. This might seem unnecessarily complicated, but it's so that the chart looks like the front (right side) of your knitting to act as a visual guide. For example, the plain boxes are stockinette stitch (knit stitches showing on the right side). The purl-dot columns (3 and 4, 12 and 13) are reverse stockinette stitch (purl stitches showing on the right side). And the alternating plain/dot columns are garter stitch (a knit with a purl on top).

Symbols with only one definition are only worked on the RS rows, so you don't need to worry about the WS versions of them.

Some charts only show the RS rows to make the chart smaller and easier to read. The row numbers are your clue: if a chart only has rows 1, 3, 5, and so forth, then only the RS rows have been charted. The pattern should explain what to do on the WS rows, and in such cases, all the WS rows are usually worked in the same manner.

If the chart is worked in the round, there will be no wrong-side definitions, and all the round numbers will be on the right side of the chart.

SAMPLE CHART 2

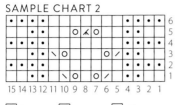

	k		O	yo		◣	ssk
•	p		�	k2tog		⟋	k3tog

Sometimes a chart is condensed by the use of a repeat box. If the same few stitches are worked over and over again, then you don't need to have the chart show all of them. For example, if your pattern says this:

Row 1: (RS) K2, (p2, k2) 4 times.

Row 2: (WS) P2, (k2, p2) 4 times.

Then your chart can use a red box in place of the brackets/parentheses. In this case, column numbers are not used.

SAMPLE CHART 3

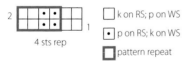

4 sts rep

	k on RS; p on WS
•	p on RS; k on WS
	pattern repeat

chart symbols

Chart symbols can differ from chart to chart. You *must* to refer to the pattern's chart key or stitch guide for specific symbol meanings. Many publishers and the Craft Yarn Council have an established list of standard symbols, those are shown here.

GENERAL SYMBOLS

☐	k on RS; p on WS
•	p on RS; k on WS
ᚱ	k1tbl on RS; p1tbl on WS
ᚱ	p1tbl on RS; k1tbl on WS
V	sl 1 wyb on RS; sl 1 wyf on WS
Ⅴ̣	sl 1 wyf on RS; sl 1 wyb on WS
▓	no stitch
+	cast on 1 st
⌒	bind off 1 st (straddles sts below)
☐	pattern repeat
•	stitch marker
‖	marker position
⟋	k2tog on RS; p2tog on WS
◣	ssk or sl 1, k1, psso or skp on RS; ssp on WS
⌄	p2tog on RS; k2tog on WS
M	M1
MR	M1R or RL1
ML	M1L or LL1
O	yo
⟋	k3tog
⤨⤧	sl 1 st onto cn, hold in back, k1, k1, from cn (RT)

CHENILLE (YARN)

See *yarn attributes, textures.*

CHULLO

See *hat styles.*

CHUNKY (YARN)

A thickness of yarn. See *yarn attributes, weights*.

CIRCULAR KNITTING

A way to knit a tube to create seamless socks, mittens, hats, sweaters, etc., using circular needles (circ) or double-pointed needles (dpn).

When you're working in the round, you're always working on the RS of the fabric, as you never turn it around. This means that to create stockinette stitch, you knit every stitch.

joining the round

double-pointed needles

You can use four or five needles total; distribute stitches across three needles and use a fourth to knit (Fig. C4) or distribute the stitches across four needles and use a fifth to knit. (Fig. C5)

Once stitches are distributed, identify the first stitch cast on, at the far end from the working yarn. (If you struggle with this, put a removable stitch marker or safety pin in the first stitch you cast on, so you can easily find it again.)

Pick up the needle with that stitch and position yourself to knit it. Grab the working yarn and knit (or purl, based on the pattern) the first stitch, pulling the yarn as tight as you can. Although the other two (or three) needles will be somewhat in the way, don't worry about them for now. The important thing is to knit the first stitch. You're then joined, and you can check to see if there's a twist, and if so, fix it. (See *fixing a twist* later in this section.)

You don't need to place a marker when working on dpn—the position of the cast-on tail indicates the start of the round. If you find it helpful, you can place a safety pin or removable stitch marker in the fabric near that position.

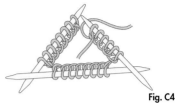

Fig. C4
working in the round on 4 dpn, working needle not shown

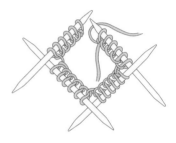

Fig. C5
working in the round on 5 dpn, working needle not shown

WORKING THE FIRST STITCH

I most often use the long-tail cast-on for working in the round, which positions the working yarn and tail end together, hanging off the last stitch cast on. To make the join a little tighter and tidier, I work the first stitch or two of the round with both the working yarn and the tail.

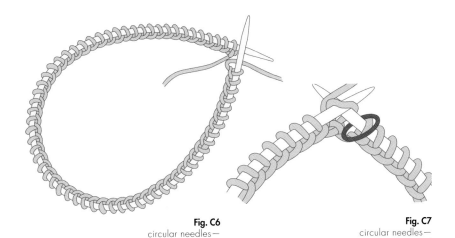

Fig. C6
circular needles —
joining the round

Fig. C7
circular needles —
joining the round

circular needles

There are various methods for joining the round on circular needles, but this is by far the simplest:

TECHNIQUE

Once you've cast on sufficient stitches to fill the needle, hold the needle so that the tip with the working yarn hanging off it is on the right, and the first stitch you cast on is on the left. (Fig. C6) Place a stitch marker on the right needle. Using the tip of the right needle and the yarn attached to it, knit (or purl, based on the pattern) the first stitch on the left needle. (Fig. C7)

Once you've joined, check to see if there's a twist, and if so, fix it. (See *fixing a twist* later in this section.)

loose joins

If your join seems loose, don't worry! As you work over the join point each round, it will tighten up. You can fix any residual looseness when you weave in the ends.

fixing a twist

The cast-on edge should sit below the needle(s), not on the top. If it does run over the top, you have a twist, which can easily be fixed in the first round. If you're using dpn, just take one of the tips of the needle that has the twist and push it through the middle of the work and back around again. If you're working on circular needles, just move the twist along the needle so it "falls" off the needle tip.

What you're doing is transferring the stitch to your cast-on edge. For most cast-on methods, this is entirely invisible. If you have a particularly prominent cast-on edge (from using the twisted German cast-on, for example), move the twist along so that you transfer it to the join, where it will be less visible.

working in the round

double-pointed needles

When you pick up your work to start, make sure that the work is positioned so that the needle with the working yarn attached to it is on the right-hand side, with the working yarn positioned close to the tip. You're always to work the stitch to the left of the working yarn.

Work across each needle in turn; when the left needle falls empty, transfer the empty needle to your right hand, shift the work slightly around to the right and begin again, working the first stitch of the next needle.

You've completed a round when you've worked across all needles, and you're back at the join point.

circular needle—full needle

When you pick up your work to start, make sure that the work is positioned so that the stitch with the working yarn attached to it is on the right needle tip.

Simply keep knitting, around and around, always working the stitch to the left of the one with the working yarn hanging off it. Make sure to keep a marker on the needle to denote the start of the round so you can keep track of your progress. If you need to put your work down, stop at least one stitch before or after the start of the round so you don't lose the marker.

magic loop/two circulars

These methods are both adaptations to permit you to work small-circumference pieces on circular needles, most popularly for sock and mitten knitting. They're both great solutions if you don't like using dpn.

magic loop

A method of working a small circumference in the round using a long circular needle. To work this comfortably, you need a long needle (typically 32–40"/80–100 cm) with a flexible cord and a smooth cord-to-needle join, so you can easily fold it and move the stitches around.

TECHNIQUE

Cast on the required number of stitches. Slide them onto the cord and count off to the center of the stitches. Pinch the cord and pull it out at this point, sliding the halves of the stitches onto the actual needle bodies. You'll have half on one needle body, half on the other. Hold the needle that has the working yarn at the back, with the working yarn hanging at the right. Pull the back needle out, moving the live stitches to the cable. To join the round, knit the first stitch on the front needle, with the back needle, pulling the yarn from the back needle. Then continue across the front needle. When you get to the end of the needle, turn your work around and work the stitches on the other needle. (Fig. C8)

two circulars

The round is divided in half, and each side sits on one needle. Each side is worked with the needle it sits on, as if you're working two separate pieces of flat knitting. This method tends to be a little faster than Magic Loop, as there is less repositioning of the stitches. The downside is that there are four needle tips flopping around.

TECHNIQUE

To begin, cast the stitches onto one needle. Slip half of them onto a second. Hold the needle that has the working yarn at the back, with the working yarn hanging at the right. To join the round, knit the first stitch on the front needle,

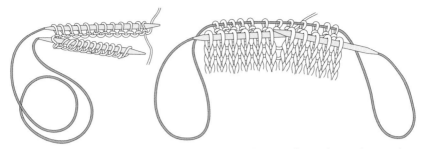

Fig. C8 working in the round — magic loop

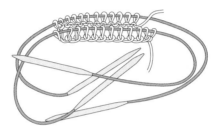

Fig. C9 working in the round — two circular needles

with the front needle, pulling the yarn from the back needle. Then continue across the front needle. When you get to the end of the needle, turn your work around and work the stitches of the other needle. (Fig. C9)

It's helpful to keep the two needles distinct in some way so you don't accidentally work with the wrong one. Consider using two different brands or types that look different. Or if they look the same, apply a bit of nail polish or permanent marker to the tips of one of them.

For a potential issue to avoid in circular knitting, see *ladders*.

DID YOU KNOW

Although it's typical to divide the stitches evenly in half for the Magic Loop and two-circulars methods, you don't have to. If it's easier to have an uneven split to help manage a pattern repeat, you can do that. If you've got 60 stitches, and you're working (k2, p2) ribbing, for example, you'd do better to have a 28–32 stitch split, rather than 30–30. This way, each side starts with k2 and ends with p2.

CHOOSING CIRCULAR NEEDLE LENGTHS

Work with a circular length that's somewhat smaller than the overall circumference of your work. For example, for a hat of a 20" circumference, you would use a 16" needle. The shortest commonly available length of circular needle is 16"; if the circumference of your piece is smaller, e.g., a sock or mitten, then you need to use a different method, e.g., DPNs, Magic Loop, or two circulars.

CIRC, CIR, CIRCULAR NEEDLE

Two shorter needles with a cord connecting them that allows for knitting in the round, especially on larger-circumference pieces. They come in varying lengths, most commonly 16", 24", 36", and 40", but longer and shorter lengths do exist.

Shorter lengths such as 12" and 8–9" aren't as common and depending on your knitting method, they can be difficult to use. The tips of the needles are very short—for the smallest ones, the needle tips are typically no more than about 1½" long. In addition, the shortness of the cord means that you can't always bend or reposition the needle tip to work increases and decreases.

CIRCULAR YOKE

See *sweater types*.

CENTIMETER

A unit of measurement in the metric system, for length. One cm equals about 0.4". See also *metric conversions*.

CLOCHE

See *hat styles*.

CM

Centimeter.

CN

Cable needle. See *cables*.

CO

Cast-on.

COBWEB

A thickness of yarn. See *yarn attributes, weights*.

COLLAR

Generally, a collar is an edging or treatment applied at the neck opening of a garment. See also *necklines and collars*.

COLORWORK, COLOR KNITTING

Knitting that uses two or more colors to create patterns or pictures. There are three main types of colorwork patterning: stranded (aka Fair Isle), intarsia, and slip-stitch/mosaic. See also *Fair Isle; intarsia; stranded colorwork; slip-stitch colorwork*.

COMBINATION KNITTING

See *knitting methods*.

CONTINENTAL-STYLE KNITTING

See *knitting methods*.

CONT, CONTINUE

See *as established.*

CORRUGATED RIBBING

A two-color ribbing pattern, common in stranded-colorwork patterns and usually worked in the round. The knit ribs are worked in one color, the purl ribs in a second color. This method causes the ribbing to lose its ability to pull in, making it more decorative than elastic.

Due to its close association with stranded colorwork, which is most often worked in the round, corrugated ribbing is usually worked in the round.

The following instructions are for k1, p1 corrugated ribbing (Fig. C10), but you can work any ribbing pattern this way.

TECHNIQUE

Cast on in 1 or 2 colors, an even number of stitches.

Ribbing round/RS rows: Both yarns sit at the back of the work: [K1 with color 1; bring color 2 to the front, p1 with color 2, return color 2 to the back] across.

WS rows: Both yarns sit at the front of the work: [Take color 2 to the back of the work, k1 with color 2, return color 2 to the front; p1 with color 1] across.

COTTON (FIBER/YARN)

Derived from the cotton plant, this fiber is heavy and absorbent and has no elasticity. Any color applied to it is likely to fade over time. Best used in garments with seams. Not suitable for lace or colorwork, since it doesn't have give required for blocking. Not suitable for winter wear. See also *fiber care.*

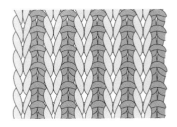

Fig. C10 corrugated ribbing

COWICHAN, CURLING SWEATER

These are both styles of a heavy knit jacket, typically worked in very thick yarn, featuring a shawl collar and intarsia colorwork designs. This style of garment originated in indigenous communities in the Pacific Northwest; the garment known as curling or Mary Maxim sweaters borrow the basic concept for fashion.

COWL NECK

See *necklines and collars.*

CREW NECK

See *necklines and collars.*

CROCHET

Another way of working with yarn. You use a single hook and work one loop at a time, wrapping the yarn around the hook and pulling it through the active loop. Different stitches are formed by creating multiple active loops on the hook and then pulling the yarn through them, either singly or in groups. Crochet is sometimes used in knitting for edgings and provisional cast-ons or to pick up dropped stitches.

crochet hook

What knitting needles are to knitting, a crochet hook is to crocheting.

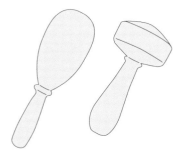

Fig. D1 darning egg and darning mushroom

DARNING EGG, DARNING MUSHROOM

Tool with a curved surface, usually wooden, over which you stretch fabric in need of repair. It's particularly useful for toes and heels of socks that have worn out, allowing easier access to small corners. (Fig. D1)

DARNING NEEDLE

See *yarn needle*.

DASH –, —

Used in a multisize pattern to indicate that a particular instruction doesn't apply to a specific size.

EXAMPLE

For first and third sizes only: Repeat the last 2 rows 1 (–, 2) more times.

A dash can also appear at the end of a section of pattern instruction indicating the number of stitches on the needles after that section has been worked.

EXAMPLE

Repeat the last 2 rnds twice more —18 (20, 22) sts remain.

DECREASE(S), DEC, DECS

To take away stitches. Some patterns aren't specific about the method; they might just say something like "decrease 1 stitch at the start of the row," which means that the knitter is free to choose the method of her preference. (Fig. D2)

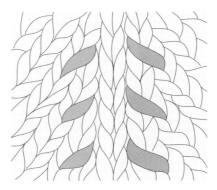

Fig. D2 k2tog and ssk decreases

Right-leaning knit	k2tog
Right-leaning purl	p2tog
Left-leaning knit	skp, ssk, k2tog tbl
Left-leaning purl	p2tog tbl, ssp
Centered double decrease	s2kpo, sk2po

decrease stitches

k2tog, k3tog,…

A right-leaning decrease. Knit the indicated number of stitches together as if one stitch.

k2tog tbl, k3tog tbl

A left-leaning decrease. Knit the specified number of stitches together, as if they are one stitch, through the back loop.

Note: This leans to the left, but it twists the stitch on top so it's not interchangeable with ssk or skp.

p2tog, p3tog,…

A right-leaning decrease. Purl the indicated number of stitches together.

p2tog tbl, p3tog tbl

Of the two left-leaning purl decreases, this is slightly easier. Insert the needle from left to right into the backs of 2 stitches—the second one first—and then wrap the yarn around the needle and complete the stitch as for a normal purl stitch. It's helpful if you swing the tip of the left needle toward yourself a little.

s2kp, s2kpo

A centered double decrease. Slip the next 2 stitches together as if to k2tog. Knit the following stitch and pass the slipped stitches over it, lifting it over and off the needle, as if for binding off. Two stitches decreased.

TIDY-LOOKING DECREASES

You can use directional decreases to create a tidy look in a knitted piece. For example, if you are working decreases at the edges of a row, it looks tidy to use a left-leaning decrease (ssk) near the beginning of a row and a right-leaning decrease (k2tog) near the end. Work the decreases one or two stitches from the edge. If you place them right at the edge, it makes the edges less tidy and harder to seam.

sk2p, sk2po

A centered double decrease that has a left-leaning stitch lying on top. Slip the next stitch knitwise, k2tog on the following 2 stitches, and pass the slipped stitch over it, lifting it over and off the needle, as if for binding off. Two stitches decreased.

Note: You can't use markers in the conventional manner with a CDD because the decrease pulls a stitch from each side of a central spine. A marker placed immediately before or after the decrease would have to be moved every time the decrease is worked. A better solution, if you need to use markers, is to place a removable stitch marker or safety pin in or around the base of the stitch that results from the decrease.

skp

A left-leaning decrease. Slip the next stitch knitwise. Knit the following stitch and pass the slipped stitch over it, lifting it over and off the needle, as if for binding off.

ssk

A left-leaning decrease. Slip the next 2 stitches, one by one, knitwise. Return the 2 slipped stitches back to the left needle without twist and knit them together through the back loop.

Note: Skp and ssk look very similar and are effectively interchangeable. If you find one easier to work than the other, just choose your favorite.

You can also work an sssk with 3 stitches to decrease 2.

Note: To make the ssk decrease look tidier, work the stitch above the decrease, in the following row or round, through the back loop. Or, some knitters prefer to slip the second stitch purlwise, as they feel this makes the stitch neater.

ssp

A left-leaning decrease. Slip the next 2 stitches, one by one, knitwise. Return the 2 slipped stitches back to the left needle without twist and purl them together through the back loop, as above.

This stitch is roughly interchangeable with p2togtbl—they aren't quite the same, but the difference isn't noticeable in most situations.

You can also work an sssp, with 3 stitches to decrease 2.

Fig. D3 double-pointed needles

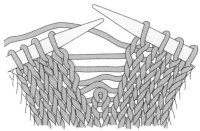

Fig. D4 dropped stitch

DECREASE EVENLY ACROSS ROW/RND

See *evenly across.*

DOLMAN

See *sweater types.*

DK (YARN)

A thickness of yarn; short for "double knitting." See *yarn attributes, weights.*

DOUBLE KNITTING (FABRIC)

Double knitting is a technique that creates a double-layer fabric. It's worked with two yarns, usually different colors, and is worked so that both sides show the right side of stockinette stitch.

There are a couple of different ways to work double knitting: one is similar to stranded colorwork, carrying both yarns at the same time, alternating yarns with each stitch; the other is worked in the manner of brioche, with one color worked at a time.

Varying which color is worked on which side creates patterns.

DOUBLE MOSS STITCH

See *moss stitch.*

DOUBLE-POINTED NEEDLES, DPN, DPNS

Knitting needles with points on each end. Used for circular knitting. (Fig. D3) See also *circular knitting.*

DROP SHOULDER, MODIFIED DROP SHOULDER

See *sweater types.*

DROPPED STITCH

A stitch that has been taken off the needle, either by accident or by design. If you've dropped a stitch by accident, and it's raveled, you can use a crochet hook to pick it up. (Fig. D4)

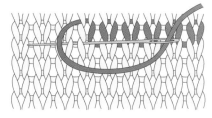

Fig. D5 duplicate stitch

DUPLICATE STITCH

A method of embroidery on the surface of a knitted fabric, so called because the shape of the stitches is the path that the embroidery thread follows. Duplicate stitch is sometimes used to weave in ends of a particularly slippery yarn. (Fig. D5)

DYELOT

Most commercially produced yarns are labeled with both a color name and the number of a dyelot. The dyelot is a way to indicate when a yarn was dyed. Color can vary radically from dyelot to dyelot. When buying yarn for a project, it is strongly recommended that you buy all the required yarn at the same time to ensure it's all from the same dyelot.

Hand-dyed yarns or yarns from smaller producers may or may not have a dyelot indicated: even within a single dyelot there can be variations between skeins. If you're working with a hand-dyed yarn, dyers recommend alternating skeins as you work to minimize any visual change in color. See also *yarn attributes, color.*

EASE

The ease measurement describes how you are wearing a garment. It's the space between you and the garment or, put another way, the difference between your measurements and the garment's. It's generally used in reference to torso/chest/bust measurements.

When a garment is larger than the person wearing it, we say it's being worn with positive ease; when the garment has the same measurements as the person in it, it's being worn with zero ease; if the garment stretches to fit—like socks or tights or exercise wear—we say it's being worn with negative ease.

Different garments need different amounts of ease, and it's proportionate through the garment. For example, if the body is being worn with about 3" (7.5 cm) of positive ease, you'd expect the sleeve to be worn with about 1" (2.5 cm) because the sleeve circumference is typically about a third of the garment circumference.

MEASURING TIP

Measure a similar item from your wardrobe to see what size it is. (Seriously, you should take a few minutes to measure your favorite sweaters, both hand- and machine-made. It's very helpful!)

ease guidelines

Many garment patterns will provide an ease recommendation, or some sort of guideline of how to wear the garment. This should guide your choice for which size to make. It is, of course, your choice how you wear a garment. You can wear a garment looser or tighter than recommended, but it won't look like it does on the model.

See also *size; measurements, body; measurements, finished.*

EASTERN UNCROSSED

Another name for combination knitting.
See *knitting methods*.

EDGE, EDGE STITCHES

Refers to the top, bottom, or sides of a piece.
See also *selvedge*.

EDGING

A strip or piece of knitting worked on or
attached to the side of a larger piece.

For example, a buttonhole edging is usually
worked after the larger piece is complete, either
by picking up stitches and knitting them or by
knitting the edging separately and sewing it on.

The term is also used to mean a pattern stitch
that's intended for use along an edge. These
are often shaped with increases and bind-offs
to create scallops or points.

ELASTICITY

When describing the characteristics of a fiber,
this means that the fiber itself has some stretch
and give and the ability to bounce back to
its original size and shape. To say a yarn is
"elastic" means the fiber itself has give, not
that there is a stretchy, elastic thread through it.

Wool has elasticity; cotton and acrylic don't. If
you've knitted with both types of fibers, you've
felt the difference: when you put the needle
into a stitch created by an elastic yarn, it will
give a little, making the movement easier; if
the yarn is inelastic, the stitch feels stiffer, and
there's more of a struggle to work it. Nylon has
a little bit of elasticity, which is why a wool and
nylon blend (common for sock knitting) feels
like pure wool when you're knitting it.

The elasticity of a fiber affects the knitting
process and the resulting fabric. A fabric

made with a naturally elastic yarn will stretch
out a little as it is worn and then return to its
original shape and size once washed. This is
why wool socks start the day snug and end the
day loose. See also *blocking; memory*.

END

Sometimes you see "end" in an instruction for
a row or a round in the context of a pattern
repeat.

EXAMPLE

Row 1: [K2, p2] across, end k2.

You're being told to alternate k2 and p2 across
all the stitches of the row, and it's expected
that you'll end with k2.

Others might phrase it like this:

Row 1: [K2, p2] to last 2 sts, k2.

These mean the same; they're just slightly
different ways to phrase it.

ending on, ending with

Used to tell you where or when to stop. If
you're working a repeat or a set of instructions
for a given distance, you often need to stop at
a certain point.

There are a few different ways to phrase it,
but they all communicate the same thing:
where to stop.

EXAMPLE

Work 10", ending on a purl row.

Work 10", ending with a purl row.

These both mean that the last thing you
should do before you stop is a purl row.

Work 10", ending with knit side facing.

That means that you should be ready to work a knit row after you have 10" complete. "Facing" is the key word here—think of it as "ready to work." You often see RS and WS used in these sorts of instructions. See *RS, WS*.

ENGLISH-STYLE KNITTING
See *knitting methods*.

ENTRELAC
A type of knitted fabric that looks like large-scale basketweave. It's worked in small sections, each built on top of the next through picking up stitches and then joined to neighboring sections through decreases. It can be worked flat and in the round—curiously, it's actually a little easier to work in the round. (Fig. E1)

EOR
End of row/round.

ERRATA
Updates or corrections to a published pattern, often found on a publisher's or designer's website. It's a good idea to check for errata before you begin knitting a pattern.

EST
Established. See *as est, as established, as set*.

ESTONIAN LACE BIND-OFF
See *lace bind-off*.

EVEN, WORK EVEN, CONTINUE EVEN
Used in knitting patterns, typically after a set of increases or decreases. It's a way of confirming that the increases or decreases are

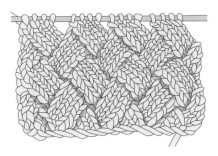

Fig. E1 entrelac

complete, and you're now to continue without changing the number of stitches.

EXAMPLE
Once increases are complete, work even until piece measures 10" from cast-on edge.

Or

Knit 10 rows even.

EVENLY ACROSS
An instruction that says to increase or decrease a certain number of stitches without dictating what increase/decrease method to use or where exactly to place them. When a designer uses this in a pattern, it means that you should simply space them out as evenly as possible using your preferred method to end up with the correct number of stitches at the end.

Note: The increases/decreases don't always distribute perfectly evenly—sometimes the numbers just won't allow that. That's fine!

Before you begin knitting the row/round, figure out and write down the distribution of increases or decreases to make sure you're happy with the arrangement and that it will result in the right number of stitches.

There are a number of different ways to approach this; these are my preferred methods.

increasing

For this type of instruction, you should use an M1 increase. (A kfb/pfb increase changes the counting and makes it more challenging.)

EXAMPLE

Increase 6 stitches evenly across 42 stitches.

Divide the number of stitches you have by the number of stitches you need to increase.

42 ÷ 6 = 7

That means you should place one increase for every 7 stitches.

From here, how you proceed depends on whether you are working in the round or in rows:

in the round

Since your knitting is continuous in the round, you can place your increases every seventh stitch:

(K7, M1) six times around.

If there's a remainder, of a stitch or more, you can do a couple of things with it.

If the remainder is only one stitch—if you're increasing within 43 stitches rather than 42—just stick that extra stitch at the end, like this:

(K7, M1) six times around, k1.

If the remainder is more than 1 stitch, you can spread them out through the round. For example, you're increasing within 46 stitches instead of 42:

(K8, M1) four times, (k7, M1) twice.

If you want to make it more even, you could spread them out like this:

(K8, M1), (k8, M1), (k7, M1), (k8, M1), (k8, M1), (k7, M1)

in rows

If you're working in rows, placing your increases at the end of each grouping won't work very well because the last increase would be right at the end of the row, and the first one is a fair distance from the start.

To resolve this, you can borrow from other groupings. To plan this out, first write out the repeat pattern:

K7, M1, k7, M1, k7, M1, k7, M1, k7, M1, k7, M1

And then take a few stitches from the first repeat and stick them at the end:

K3, M1, (k7, M1), (k7, M1), (k7, M1), (k7, M1), (k7, M1), k4.

Written out more concisely, it's this:

K3, M1, (k7, M1) five times, k4.

If there's a remainder, stick the stitches at the end or use them to space out the increases.

EXAMPLE

Increase 17 stitches evenly across the 130 of the current row.

130 ÷ 17 = 7.64 (this means increase every 7 stitches, with 11 stitches left over).

I start with this:

(K7, M1) seventeen times, k11.

You could also choose to take a couple of the 11 from the end and stick them at the front, like so:

K2 (k7, M1) seventeen times, k9.

Which puts the same number of stitches at the start and end of the row.

You could also take some of the 11 and then distribute them through the row, to space things out more, like this:

(K7, M1) six times, (k8, M1) four times, (k7, M1) seven times, k7.

There's no wrong answer with an instruction like this, as long as you get the right number of stitches at the end. If the designer hasn't been specific, it's really your choice!

decreasing

If the designer hasn't suggested a specific decrease, then keep it simple and use k2tog.

Distributing decreases is very similar to distributing increases, with one key difference: the decrease goes *within* each grouping of stitches, instead of at the end.

EXAMPLE:

Decrease 6 stitches evenly across 42 stitches.

Divide the number of stitches you have by the number of stitches you need to increase.

42 ÷ 6 = 7.

Therefore, decreasing every 7 stitches with a k2tog looks like this:

(K5, k2tog) 6 times.

Just as with increases, use the same tricks to make things more even: steal stitches from the start to put at the end. If there's a small remainder, stick the stitches at the end; if there's a big remainder, distribute the stitches throughout. As long as you have the correct number of stitches at the end, you're good!

E-WRAP

See *backward-loop cast-on*.

Fig. E2 eyelets

EYELASH (YARN)

See *yarn attributes, textures*.

EYELET

A hole deliberately created in knit fabric by using a yarnover. Eyelets are sometimes used as buttonholes, or they can be arranged in a piece as decoration. A fabric with many holes arranged in a decorative pattern is usually referred to as lace. (Fig. E2)

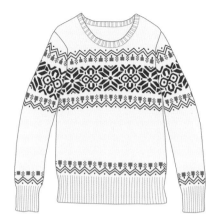

Fig. F1 Fair Isle sweater

FACING

Read as "facing you," it's used to tell you which side of the fabric you should be looking at when working a particular step in a pattern.

EXAMPLE

With RS of the sleeve facing, pick up and knit 10 stitches . . .

FAGOTING, FAGOT-STITCH

A simple two-sided lace pattern, usually a two-stitch repeat involving a yarnover and decrease, most common in Shetland-style lace. It's worked in columns, working the repeat on both sides over the same stitches to create a very open, net-like pattern. It looks quite different from most knitted fabrics.

FAIR ISLE

Colorwork stitch patterns and technique common to the Shetland island of Fair Isle, usually worked in two colors at a time. Fair Isle is also often used as a general term for stranded-colorwork knitting, whether the patterns are traditional or not. (Fig. F1)
See also *colorwork, colorwork knitting; stranded colorwork.*

FASTEN OFF

To secure the final stitch or stitches when binding off. The yarn is usually cut (leaving a 4–6" tail) and pulled through the loop of the final stitch.

Sometimes a piece such as a hat or mitten isn't bound off, but rather decreased down to a small number of stitches, and the yarn is cut (leaving a long tail), threaded onto a yarn needle, and run through all the remaining stitches. For this type of closure, you need to pull it tight and then securely weave in the end.

FAUX ISLE

See *yarn attributes, color.*

FC

Sometimes used for "front cross" in a cable pattern. See *cables.*

FELT, FELTING

A fabric created from wool. The process of creating felted fabric using knitted or woven fabrics is properly known as fulling, although this is commonly referred to as "felting."

Untreated (i.e., non-superwash) sheep's wool fibers have scales on the surface; when the wet fiber experiences temperature shock, agitation, or friction, the scales stand up, and the fiber strands effectively collapse down like an umbrella, grabbing onto themselves (and each other). The fibers aren't shrinking, they are changing shape, getting shorter and wider. The process is irreversible.

You create felt from unspun fiber (roving), either by wetting the fiber and agitating it or through the use of special long, sharp needles sometimes with barbs. Needlefelting is better for creating sculpted shapes, rather than flat fabrics.

To full a knitted fabric, you run it through a washing machine in hot water or a cycle in a hot clothes dryer while wet along with some old towels and tennis balls or other items to create friction. You can also handfelt fabrics by immersing them in water and rubbing or agitating the fabric. (Although inelegant, a bucket and a plunger work fantastically well!) Soap helps encourage the process, as its chemical composition causes the scales on the wool fiber to stand up.

See also *superwash wool.*

FIBER

Generally speaking, the material that makes up yarn.

FIBER CARE

Different fibers require different treatments for washing. The yarn label should give a sense of what is required, either in a description of use or through laundry-care symbols.

FIBER	CARE
ACRYLIC	Machine wash & dry
ALPACA	Handwash
ANGORA	Handwash
BAMBOO	Delicate machine wash
CAMEL	Handwash
CASHMERE	Handwash
COTTON	Machine wash; air-dry is best. Machine dry is possible, but can hasten fading and shrinking.
HEMP	Machine wash & dry required to soften
LINEN	Machine wash & dry
LLAMA	Handwash
MOHAIR	Handwash
NYLON	Machine wash & dry
POSSUM	Handwash
QIVUIT, QIVIUK	Handwash, although not prone to felting
RAYON	Handwash
SILK	Handwash
SUPERWASH WOOL	Delicate machine wash; not guaranteed to be suitable for the dryer
VICUÑA	Handwash
WOOL	Handwash
YAK	Handwash

fiber care symbols

You sometimes see these on yarn labels. The tub indicates washing instructions, the square drying instructions. These are the ones that are relevant to knitters:

SYMBOL	MEANING
(washtub symbols, 60°, dots)	Machine washable; number or dots convey temperature: the more dots/higher the number, the hotter the wash
(hand in tub symbol)	Handwash only
(circle in square symbol)	Safe for machine drying. Dots or numbers give a sense of temperature
(square with horizontal line)	Dry flat
(square with top line)	Hang dry
(circle symbol)	Dry-cleanable

machine wash

Avoid the machine where possible; agitation can cause fabrics to pill and stretch. If you do need to wash in the machine, use the gentlest cycle possible. A short and cool (rather than hot or cold) wash is best, with the gentlest soap/detergent. Put the item in a mesh wash bag (or even tied up in a pillowcase) so that it doesn't get flung around and stretched out.

A front-loading machine is better for knits than a traditional top-loader with the central agitator column that can trap pieces and pull them out of shape.

Also, don't be afraid of the spin cycle. This cycle uses centrifugal force to press the item against the side of the tub and "spin" water out of it. It's entirely safe, for even the most delicate knit fabrics and yarns, since the item doesn't move around, keeping it from felting or stretching. The higher the speed the better, as there's even more force keeping the items in place on the side of the tub, and even more water is removed.

handwash

Fill a tub or bucket with cool water, put a squirt of your chosen wool wash or detergent in (see the product label for guidance on the quantity), and mix it up. It may or may not generate much in the way of suds. Soak the pieces for the required time—usually about 20 minutes—and then pour out the water. Gently squeeze out as much water as you're able without twisting. If you're using a no-rinse wool-wash, then no rinsing is required; otherwise rinse gently, with as little agitation as possible.

To remove more water, either put the item in your washing machine for a spin (yes, really!) or lay it on a towel and roll it, pushing down to force the water to absorb into the towel. If it's a larger piece, I put the towel down on my tiled laundry room floor, roll it up, and step on it.

dry-cleaning

The solvents used for dry-cleaning can be harsh, therefore it is not recommended for cleaning handknits.

detergents and soaps

For your most delicate fabrics and fibers, a no-rinse wool wash is best. These products are

specifically developed so that they don't need to be rinsed off fabrics. Use a wash specifically designed for washing wool and silk or a gentle, plain shampoo. (Baby shampoo is best. Avoid shampoos with added conditioner or that are heavily scented.)

Modern laundry detergents often have enzymes in them to break down stains. One type of enzyme in particular, proteases, attacks proteins, which is ideal for getting food stains off fabrics. The problem is that wool is a protein fiber, so these types of detergents attack and weaken the fibers. In the United Kingdom and Europe, products labeled "non-bio" don't have the enzymes.

Avoid traditional soaps, as their high pH level (meaning they're very alkaline) can encourage felting.

drying

Once the piece has been spun or wrung out by hand, you have three options: machine dry, hang dry, or lay flat to dry.

Even if a yarn is described as being machine dryable, knits will last longer if you let them air-dry. Fabric tumbled in a clothes dryer tends to pill due to the friction of the item tumbling against itself and other clothes in the load; and the tumbling motion can cause pieces to stretch out of shape.

If you need to use the dryer, you can minimize pilling and stretching by putting the item either in a mesh wash bag or on a flat rack inside the dryer, if your machine offers this handy option.

Unless the item is small, like a sock or mitten, avoid hanging things to dry, as the weight of the wet fabric will stretch the piece out. For small pieces, a clippy hanger is a great help.

The best place to dry a knit is lying flat, on top of a laundry rack or similar. (I use the dog's crate, with a towel stretched out on top.) Commercial sweater dryers work well: they are mesh fabrics that fit over a frame, allowing air to circulate underneath the piece. Lying the piece on the floor or a bed or other solid surface means a longer drying time; if the piece isn't well wrung out, you risk mildew.

FINISHED MEASUREMENTS

These are the measurements you'd get if you put the finished, blocked item on a flat surface and took a tape measure to it. They might be listed in written form or given as a visual (a schematic). If a garment pattern doesn't list finished measurements, then avoid it. It's not providing enough information.

Finished measurements are crucial for garments as well as for simpler items such as scarves to understand sizing. Photographs of the item communicate some of this information, but without numbers, you'd be guessing at sizing.

For a sweater, you should see at minimum a chest/bust measurement and a length from shoulder to bottom edge. Compare these with the measurements of existing sweaters in your wardrobe to get an idea of how it will fit you.

You would rarely work a garment to be the same as your own body measurements. Most often, a handknit garment is worked with positive ease.

You can use finished measurements as a way to virtually try the garment on, too: hold the tape measure at the body circumference listed, around your own torso to get a sense of how the garment will fit you.

See also *blocking; ease; measurements, body; measurements, finished; schematic; size.*

FINISHING

This term covers all the final steps to completing a knitted piece, such as blocking, seaming, and weaving in ends. See also *blocking; seaming; weaving in ends.*

FINGERING (YARN)

A thickness of yarn. Watch the spelling: don't confuse it with fingerling, which is a tiny potato. See *yarn attributes, weights.*

FISHERMAN'S RIB

A stitch pattern that results in a similar knitted fabric as brioche stitch but worked differently. It's commonly worked by knitting the stitch below the stitch on the needle followed by a standard knit stitch, with the doubled stitches created every other row. The fabric lies flat, making it good for pieces such as scarves and blankets. See also *brioche.*

FIT, TO FIT

See *ease; size.*

FLAP-AND-TURN HEEL

Refers to the heel of a sock. There are many variations of this style, for both top-down and toe-up constructions. Flap-and-turn heels most often have gussets.

heel flap

The flap is a section of the sock that sits vertically on the foot, at the back. It can be worked plain in stockinette stitch or in a stitch pattern.

Depending on shoe fit, this section of the sock can be very prone to wear. Many knitters work a reinforcement pattern stitch in this area, often using slipped stitches to create a double-thickness fabric.

heel turn

The heel turn is so called because the fabric is folded over to change the direction of the knitting. The fold is most often created through decreases.

See also *gusset; sock anatomy.*

FLOAT

A strand of yarn that sits on the back (WS) of the fabric. If you're working with two colors, in stranded colorwork, it's the strand of yarn in the color you didn't knit with. In slipped-stitch fabrics, it's the strand that sits behind the stitches that aren't worked. See also *colorwork, color knitting; slip-stitch colorwork.*

FLUFFY (YARN)

See *yarn attributes, textures.*

FO

Short for "finished object"—a colloquialism for a finished knitted piece.

FOLL

Following.

FOLL ALT, FOLLOWING ALTERNATE

Because of the way decreases and increases are worked, it's common to see this phrase.

EXAMPLE

Decrease at the start of the row on every foll alt row, until 10 stitches remain.

This means you should work the decrease instruction on every other row from this point until you're told to stop. In this case, you're

told to stop when you hit a certain number of stitches. In other cases, you might be given a number of times to work, like this:

> Decrease at the start of the row on every foll alt row, 5 times.

FRINGE

A decorative edge treatment, created with short strands of yarn knotted onto the edge.

FROG

A common term for unraveling your knitting. If you are going to undo knitting, you might say you are going to "rip it," which sounds a bit like "ribbit," the popular transliteration of the sound a frog makes. Undoing your work in this way is also known as making a visit "to the frog pond." See also *tink*.

FULLING

See *felt, felting*.

FUNNEL NECK

See *necklines and collars*.

FUZZY (YARN)

See *yarn attributes, textures*.

G
Gram(s). A metric weight measurement.

GANSEY
A traditional British style of fisherman's sweater, common in the fishing communities of England and Scotland. The design is more practically minded than an Aran-style sweater, and the patterning therefore simpler.

GARTER STITCH
Knit every row in flat pieces; knit a round, purl a round while working in the round. Stitch count is not a factor, and the right and wrong sides look exactly the same. Garter stitch tends to stretch out vertically over time. The fabric lies flat, making it good for pieces such as scarves and blankets.

Because of the way the fabric gathers up, it's challenging to count rows one at a time in garter stitch, so we count ridges instead. One ridge = two rows. (Fig. G1)

garter ridge ➔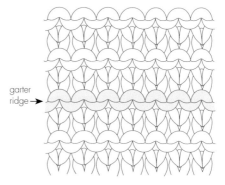

Fig. G1 garter stitch

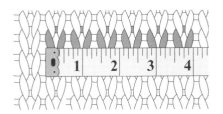

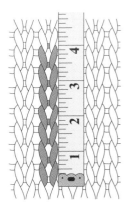

Fig. G2 stitch gauge

Fig. G3 row gauge

GAUGE

Gauge is a measurement of knitting tension that is used as a guideline in patterns to help you identify the type/thickness of yarn to use and make sure your knitting will produce the right-size pieces. Achieving accurate gauge is critical for getting good results with fitted garments such as socks and sweaters. It's not as critical for pieces such as scarves and blankets.

The standard format for expressing gauge is as follows:

EXAMPLE

of stitches/# of rows = 4" (10 cm) in pattern stitch using size ___ needles.

20 sts/28 rows = 4" (10 cm) in stockinette stitch using size U.S. 7 (4.5 mm) needles.

Similar information will be listed on the yarn label. Buy yarn that lists a gauge that matches whatever your pattern calls for. Stockinette-stitch gauge is treated as a standard measurement for yarn thickness, so yarn labels always list that information.

These numbers aren't arbitrary: the "gauge" of a yarn represents how many stitches and rows you can count in 4" (10 cm) on a patch of good fabric worked with that yarn. After all, you can work any yarn with any needles, but if you work with needles too small, you'll get a stiff and tight fabric; if you work with needles too big, you'll get a loose and sloppy fabric. So the gauge measurement is a way to communicate how the yarn should be worked to create a good fabric.

how to check gauge and choose needles

The needle size listed in a pattern is the size the designer used to make the project. Since every knitter knits differently—some looser, some tighter—you may need to use different-size needles to achieve the required gauge.

To measure gauge, knit a swatch—an about 4" (10 cm) square of stockinette stitch. From there, you count how many stitches and rows you have within that square.

make a swatch

1. To figure out how many stitches to cast on, first look at the gauge listed on the pattern. Take the number of stitches in 4" (10 cm) and multiply that by 1.5. The result is how many stitches to cast on. For a 20-stitch gauge, cast on 30 stitches. For a 12-stitch gauge, cast on 18 stitches.

2. Using the needles listed in the pattern, work stockinette stitch until your piece is about 5" (12.5 cm) long. If gauge is listed in rows, work the piece flat; if the gauge is listed in rounds, work in the round.

3. Bind off and wash the swatch. Wash it the same way you'll wash the finished project—in a machine or by hand. This step is critical, since yarns and fabrics can change when they're washed, and you need to know if it's going to stretch or shrink.

If you're air-drying the swatch, lay it flat to dry. Don't pin it or stretch it—unless of course you plan to pin or stretch the finished garment every time you wash it.

4. Use a ruler to carefully measure 4" (10 cm) across and count the stitches (Fig. G2), and then measure 4" (10 cm) up and down and count the rows/rounds. (Fig. G3)

The objective is to match the number of stitches precisely. And you need to get very close on the number of rows. Stitch gauge is critical, but for most types of pattern, a minor difference in row gauge doesn't matter.

• **If you match precisely:** You've got the right needle size. You're ready to go!

• **If you're getting too many stitches:** For example, if the pattern gauge is 20 stitches, and you're getting 21, then it means your

GOOD REASONS TO SWATCH

• Swatching allows you to audition the yarn: to see how it looks knitted up, to determine how it feels, to decide if you like working with it.

• Swatching is a nice way to learn the pattern stitch.

• Swatching is a great way to test the washing instructions on the ball band of the yarn: if you want to be confident the garment is machine washable, better to test a swatch than a whole sweater.

stitches are too small. Try again with the next size needle up.

• **If you're getting too few stitches:** For example, if the pattern gauge is 20 stitches, and you're getting 19, then it means your stitches are too big. Try again with the next size needle down.

• **If you're more than about 10% off:** For example, if you're trying to get to 20, and you're getting a nice fabric with a count of 16 or 24 stitches in 4" (10 cm), then you need to change the yarn. That big a change in stitch gauge will absolutely compromise the fabric. Of course, you can knit any yarn at any gauge, but it's about making a nice fabric.

• **If your stitch gauge is good, but your row gauge is a little bit off:** As long as it's

Work the swatch in the pattern stitch. Make sure you're casting on enough stitches to get a swatch at least 4" (10 cm) wide with complete pattern repeats. That is, if the pattern requires you to check your gauge over a lace stitch with a 16-stitch repeat, you'll likely need to cast on two or three repeats' worth of stitches.

Once in a while, you'll see a gauge listed for ribbing, with the guidance that it should be measured while "lightly stretched." In these circumstances, you can get away with knitting a stockinette swatch instead because a "lightly stretched" ribbing fabric has the same effective gauge as stockinette stitch worked with the same needles.

not a really complicated shaped garment, then you're good to go.

• **If your stitch gauge is good, but your row gauge is way off:** You need to consider if row gauge matters for the project or not. If it's unshaped—a scarf, shawl, or baby blanket—then it doesn't matter. But you should buy extra yarn, as your yarn usage will be different than predicted. If it's a shaped item—a sock or a garment, for example—then row gauge does matter.

GM
Gram. See also *metric conversions*.

GRADIENT
See *yarn attributes, color*.

GRAFT, GRAFTING
See *Kitchener stitch/grafting*.

GRAM
A unit of weight in the metric system, often used for labeling a ball or skein of yarn. One ounce is equal to 28 grams (g). Yarns are often sold in 50 g or 100 g quantities. See also *metric conversions*.

GUSSET
A tailoring term for a triangular-shaped piece of fabric used to shape or size a piece of clothing. Gussets are most often used in mittens, gloves, and socks, but they also appear at the neckline and in the underarms of traditional ganseys. A gusset provides shaping that allows the piece to better match the shape of the body. See also *mitt, mitten; sock anatomy*.

HALO

Referring to a yarn or a fabric that has a fluffy texture. Mohair and angora both have significant halos. See *yarn attributes*, *textures*.

HAND-DYED

See *yarn attributes*, *color*.

HANK

Another term for skein. See *put-up*.

HAT STYLES

See Fig. H1 for common styles.

beanie

A style of hat, close-fitted to the head.

beret

A style of hat, snuggly fitted around the ears, and expanding out to create a flat crown. Similar to a tam, but smaller.

bonnet

A close-fitted hat that fully covers the back of the head and ears, down to the nape of the neck; open around front of the face; may or may not have a flared brim.

chullo

A fitted hat with earflaps, often with strings ending in tassels or pom-poms attached to the top of the crown and the base of the flaps.

cloche

A close-fitting hat that sits lower over the ears and face, with a small brim.

tam

Close-fitted and deep lower band with a larger, loose crown. Band is typically deeper and crown larger than a beret, and the join between band and crown has a gathered effect.

Fig. H1 hat styles

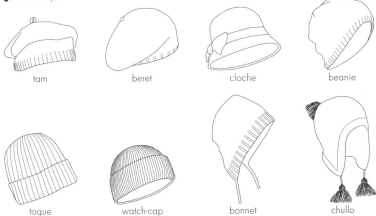

tam beret cloche beanie

toque watch-cap bonnet chullo

toque

Common Canadian usage, a fitted hat like a beanie. May or may not have a pom-pom.

watch-cap

Close-fitted hat, with a fold-over cuff. Never has a pom-pom.

HEEL

Although there are some more innovative and unusual constructions, sock heels are generally worked in one of two ways: a one-piece short-row heel or a two-step flap-and-turn method. They are usually worked on half the number of stitches you have for the sock leg.

See also *flap-and-turn heel; short-row heel; sock anatomy*.

HELICAL STRIPES

See *jogless jog*

HEMP (FIBER/YARN)

Derived from the hemp plant. A heavy yarn that can feel harsh at first, but softens well over time and is hard-wearing. Excellent for bags. In blends, it behaves very much like linen, creating a terrific breathable fabric. See also *fiber care*.

HENLEY

See *necklines and collars*.

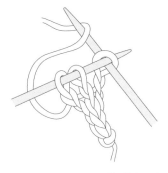

Fig. 11 I-cord

I-CORD

This simple technique used to create a knitted cord was named "idiot-cord" by Elizabeth Zimmermann, which is usually shortened to the more polite "I-cord."

It is most easily worked with a short circular needle or a pair of dpn. Cast on three or four stitches. Knit one row. At the end of the row, do not turn, but slide the stitches along to the other end of your short circular/dpn and knit them again. Each time you knit the first stitch, pull the working yarn snug across the back of the stitches; this causes the edges of the row to curl together, creating a cord.

I-cord can also be produced using a spool knitter or a hand-crank device known as an "I-cord machine," which automates the process.

ICELANDIC YOKE, OR "LOPAPEYSA"

Worked in the round with the thick but light and absurdly warm wool of the native Icelandic sheep, these sweaters are considered outerwear in their home country. They feature stranded-colorwork patterns around the circular yoke.

INCHES (IN, INS)

An imperial measurement of length, equivalent to 2.54 cm. See also *metric conversions.*

INCL

Including.

INCREASE(S), INC, INCS

To add stitches as you knit. There are two categories of increases: those that make new stitches from an existing stitch and those that make a new stitch where there wasn't one before.

making new stitches
from an existing stitch

These increases all have you work multiple times into an existing stitch. You sometimes see these described as "increasing in a stitch."

Create 2 stitches from 1	kfb, pfb
Create 3 stitches from 1	kfbf, kyok

kfb, k1f&b, kfbf

Knit through the front and back loop of a single stitch, making 1 stitch into 2. This increase creates a bump on the left side of the original stitch, so if you're working multiple increases in a row, you need to place them carefully if you want the bump to always appear in a certain place.

Kfbf is worked by knitting through the front loop, back loop, and front loop again of a single stitch. It increases the stitch count by 2 stitches.

kyok

An increase that turns 1 stitch into 3. Work (knit, yo, knit) into the same stitch. A version of this increase is used to create a nupp. As with kfb, you can increase the number of times it's worked, e.g., working (k1, yo, k1, yo, k1) into the same stitch. This tends to make a small hole.

pfb, p1f&b

Purl through the front and back loop of a single stitch, making 1 stitch into 2. This increase creates a bump on the right side of the original stitch, so if you're working multiple increases in a row, you need to place them carefully if you want the bump to always appear in a certain place.

TIP

Why Different Increase Types Are Not Interchangeable

If you have ten stitches and your instruction says:

K9, M1, k1

you're being asked to make a stitch where there wasn't one before. If you use a kfb (or pfb) instead of M1, you'd use up the last stitch of the row and wouldn't be able to complete the instruction. They also look very different—the kfb and pfb increases create a little bump.

making a new stitch where
there wasn't one before

If a pattern asks for an M1 increase without giving a specific definition, or says to "make a new stitch," you can use any methods listed here. These are all effectively interchangeable.

An increase that creates a little hole	yo
A relatively neutral increase	backward-loop method
Make 1 stitch, left leaning	M1L, M1PL
Make 1 stitch, right leaning	M1R, M1PR
Make 1 stitch using stitches from a previous row	LLI, RLI

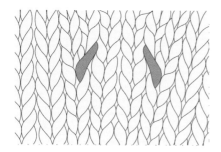

Fig. 12 LLI and RLI increases

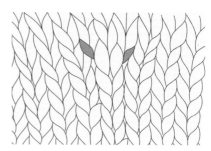

Fig. 13 M1L and M1R increases

lli

A left-leaning lifted increase. (Fig. 12)

TECHNIQUE

Use the tip of the left needle to grab the left leg of the stitch 2 rows below the one on the right needle and place it on the needle so that it's right-leg forward. Knit into this strand. Also known as the grandmother increase, as you use the "grandmother" of the first stitch on the right needle.

rli

A right-leaning lifted increase. (Fig. 12)

TECHNIQUE

Use the tip of the left needle to grab the right leg of the stitch one row below the one on the left needle and place it on the needle so that it's right-leg forward. Knit into this strand. Also known as the mother increase, as you use the "mother" of the first stitch on the left needle.

backward-loop make 1

This is the same as the backward-loop cast-on method. It creates an easy and relatively neutral, i.e., neither left- nor right-leaning increase. It can leave a bit of a hole when working with larger yarn. If you need matching left and right versions, you can twist the yarn in the opposite direction to create the reverse loop.

m1l/m1pl

An increase that makes one new stitch, left leaning. (Fig. 13)

TECHNIQUE

Using the tip of the left needle, lift strand that runs between the last stitch on the right needle and the first stitch on the left needle, from front to back, and work that strand through the back loop. If it's M1L, knit it; if M1PL, purl it.

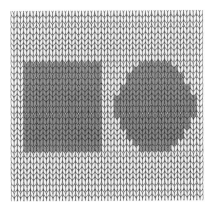

Fig. 14 intarsia

Fig. 15 intarsia (picture) sweater

m1r/m1pr

An increase that makes one new stitch, right leaning. (Fig. 13)

TECHNIQUE

Using the tip of the left needle, lift strand that runs between the last stitch on the right needle and the first stitch on the left needle, from back to front, and work that strand through the back loop. If it's M1R, knit it; if M1PR, purl it.

yarnover, yo

To bring the yarn over the needle to create a new stitch; to create a deliberate hole in knitted fabric. Often used in lace or openwork for a decorative effect. Can be worked wrapping the yarn from front to back wrapping over the needle or back to front depending on the surrounding stitches. Patterns should indicate which direction to wrap the yarn. See also *yarnover.*

INTARSIA

A method of working with multiple colors to create designs and pictures in the knitted fabric (Fig. 14). Each color is used separately, for individual sections of the fabric, requiring a separate ball of yarn for each color in a row. Bobbins—little spools or frames around which you wind yarn—can be helpful for holding the yarn, or some knitters simply use smaller balls or butterfly-twists of yarn. When you change color, you drop the first yarn and pick up the second, twisting the two around each other. It is most commonly worked in stockinette stitch, in rows. Although it's possible to work intarsia in the round, it's challenging and requires short-rows.

Intarsia can also refer to an otherwise plain sweater with a large motif or character picture on the front. Popular for children's wear. (Fig. 15) See also *bobbins; colorwork, color knitting.*

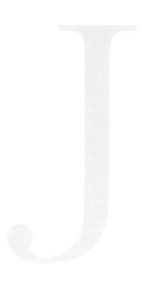

JENY'S SURPRISINGLY STRETCHY BIND-OFF

A bind-off method attributed to Jeny Staiman closely related to the older yarnover bind-off method. It works well when binding off the cuff of toe-up socks or other times a stretchy bind-off is needed.

The basic method is that you work a yarnover before each stitch and pull the yarnover over the stitch once it's been worked.

If the stitch to be bound off is a knit stitch, work a backward yo (bring the yarn to the front over top of the needle). Knit the stitch and pull the yarnover over the stitch. If the stitch to be bound off is a purl stitch, work a standard yarnover. Purl the next stitch and pull the yarnover over the stitch.

Work across as per a standard bind-off, adding the yarnover to each stitch.

JOG, JOGLESS JOG

When you're working in the round, the start and end of a round don't line up—you're actually working in a spiral. It's not visible in a solid color, but the offset, referred to as the jog, is plainly visible if you're working stripes. Even commercial or machine knits have this issue. (Fig. J1)

There are a few ways to mitigate this effect and create a "jogless jog." (Fig. J2) These are my favorites.

slip-stitch method

This is for when the stripes are at least three or four rounds tall. On the first round of the stripe, join the new color and work to the end of the round. Instead of working it, slip the first stitch of the second round purlwise and then complete the stripe normally. This brings the first stitch of the first round of this color up and into line with the last stitch of that first round.

Fig. J1 jogged stripe

Fig. J2 jogless stripe

knit into the row below

For stripes deeper than one round. On the first round of the stripe, join the new color and work to the end of the round. At the start of the second round, use the tip of the right needle to pick up the right leg of the stitch below the first stitch on the left needle—this will be in the previous color—put it up on the left needle (right leg forward) and work k2tog on that and the first stitch of the round. This will pull up the first stitch of the new color to line up with the last.

helical stripes

This is for one-round stripes, with two to four colors. Divide the stitches into as many groups as there are stripes. If there are four colors, divide the stitches up into four groups. Join the first color at the start of the first group and work across it; drop it, join the second color at the start of the second group, and work across those stitches; drop it, join the third color at the start of the third group, and so forth. The yarns spiral around as you work; you just work the stitches with the available yarn. On the second round, you will work the first group of stitches with the fourth yarn, the second group of stitches with the first yarn, and so on.

JOIN FOR WORKING IN THE ROUND

See *circular knitting*

JOINING YARN

Whenever you run out of yarn partway through a project or need to work a new color, return to previously held stitches, or add stitches to a different part of your knitting, you have to join yarn. There are a variety of methods, and which you choose depends on the situation, the type of yarn, and personal preference.

Note: You need roughly three times the width of the row in yarn to be able to work all the way across. If you have less than that, you'll have to join new yarn partway along.

when a ball ends

at the end of a row

If a piece is being worked flat, and the edges are going to be seamed up, then it's best to join at the start of a row, so that the tails can be woven into the seam. My favorite method for this is very simple: Tie the new yarn around the tail of the ending yarn, using a simple underhand knot. Pull it snug but not so tight you can't undo it. This allows you to pull the new yarn up to the top and keeps the last stitch of the old yarn and the first stitch of the new yarn anchored together and tidy, so they don't get sloppy or risk coming undone. You can choose to undo the knot when you weave the ends in, but I generally don't.

in the middle of a row

If the piece is being worked in the round, or if the edges are going to be exposed—a scarf, for example—then you need to join in the middle of the piece. My preferred way to do this is to work the two yarns together for a few stitches, as follows:

Hold the new yarn alongside the old, with the ball end of the new lined up with the tail end of the old and work three stitches—no more!—with both held together. Treat those doubled stitches as one on the following row/round.

Although it does thicken up those stitches a little, because it's only three stitches, it's really not noticeable in the finished result. If you're worried, try to make the join somewhere less visible: under the arm or on the back of a garment worked in the round, for example. You will need to weave in the yarn ends when the project is complete.

spit-splicing

If the yarn is a wool that felts—that is, an animal fiber that hasn't been treated to be machine washable—you can also spit-splice. Split the plies of the yarn and lay the two pieces end-to-end, mingling the split plies. Wet the yarn in this area: your own saliva works best, as there are enzymes that hasten the felting, but water also works. If you do wish to spit, make sure that your saliva isn't colored by the red wine, coffee, or tea you were just drinking! Rub the strands together in your palms until they felt and stick together.

Some knitters choose to thin the two strands along the length that you will join, removing a couple of plies, so that the spliced section is about the same thickness as the original yarn. If you do this, make sure that you felt down the full length of the thinned section, including the ends of the shortened plies.

The advantage to this method is that it eliminates the need to weave in any ends, but it only works with a yarn that felts.

JUMBO

A thickness of yarn. See *yarn attributes, weights*.

K
Knit.

K2TOG, K3TOG, . . .
See *decreases*.

K2TOG TBL, K3TOG TBL, . . .
See *decreases*.

KAL
Abbreviation for "knit-along," when a group of knitters work on the same project at the same time. It's often organized through a yarn shop or on social media, and there are sometimes meet-ups, classes, or tutorials offered to provide assistance with the pattern.

KEEPING PATTERN CORRECT
In a set of instructions, this phrase is used in situations where a pattern stitch is being worked, e.g., a ribbing or lace pattern, and the stitch count is changing. You might be working increases up a sleeve from the cuff or decreases to shape the armhole of a garment piece. It's a reminder that you need to keep working the pattern stitch and ensure it remains aligned.

KETTLE-DYED
See *yarn attributes, color*.

KFB, K1F&B, KFBF
See *increases*.

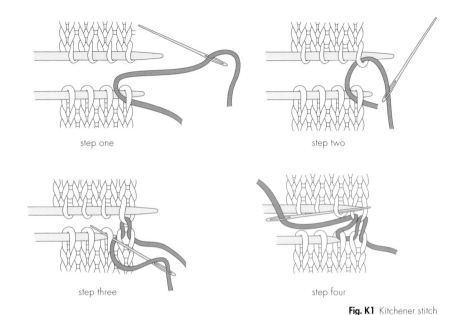

step one

step two

step three

step four

Fig. K1 Kitchener stitch

KITCHENER STITCH / GRAFTING

A method to seam together two sets of live stitches, resulting in an invisible join with no seam allowance or ridge on the inside. It was popularized by Lord Kitchener of the British Army during World War I.

To work Kitchener stitch when both sides of the join are stockinette stitch (Fig. K1):

TECHNIQUE

Cut yarn, leaving a tail about 4 times the length of the row, and thread onto a yarn needle.

Step one: Bring threaded needle through front stitch as if to purl and leave stitch on needle.

Step two: Bring threaded needle through back stitch as if to knit and leave stitch on needle.

Step three: Bring threaded needle through first front stitch as if to knit and slip this stitch off needle. Bring threaded needle through next front stitch as if to purl and leave stitch on needle.

Step four: Bring threaded needle through first back stitch as if to purl and slip this stitch off needle. Bring needle through next back stitch as if to knit and leave stitch on needle.

Repeat Steps three and four until no stitches remain on needles.

There are variations for joining other fabrics—reverse stockinette stitch, garter stitch, and ribbing.

KNIT

A fundamental stitch. To work a knit, hold the working yarn in the back. Put the tip of the right needle into the front leg of the first stitch on the left needle from left to right; wrap the yarn around the tip of the right needle, from the front over to the back, and around to the front. Take this strand back through the stitch on the left needle and let the stitch slip off the left needle so that the new stitch sits on the right needle.

The direction that the needle tip is inserted into the stitch and the direction of the yarn wrap are important. The resulting stitches are mounted so that the right leg of the stitch is always at the front of the needle.

KNIT BELOW

To knit (or purl) below is to work into the loop of the stitch that hangs under the needle, rather than the loop that's on the needle. The stitch that results is doubled—it has two strands of yarn—and is slightly elongated. It is one way of working Fisherman's rib. See also *brioche; Fisherman's rib.*

KNITTED CAST-ON, KNITTING ON

Like the backward-loop method, this is often taught to beginners. It produces a very firm edge, without give, but it also has loose loops that tend to roll up. It's best used if you need to add new stitches onto an existing piece of knitting, at the start or end of the row. It's not a great edge if you need to seam it. It requires two needles. (Fig. K2)

TECHNIQUE

If there are no established stitches, begin with a slipknot placed on the needle in your left hand.

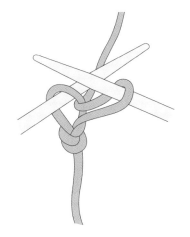

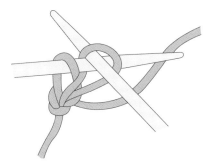

Fig. K2 knitted cast-on

As if you're knitting, put the tip of the right needle into stitch, wrap the yarn around, bring it through; leaving the previous stitch on the left needle, pull the new loop out a little and place it on the left needle. Repeat, knitting into this new stitch, until you have the stitches you need.

Some choose to put a twist in the edge. Knit into the stitch the same way; when you pull the loop out, turn the tip of the needle to the right, away from you, so that the loop twists before you put it on the left needle.

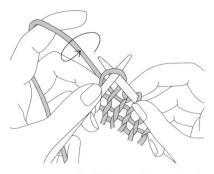

Fig. K3 knitting Continental-style

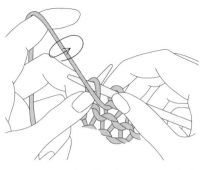

Fig. K4 purling Continental-style

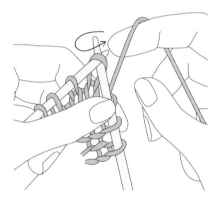

Fig. K5 knitting English-style

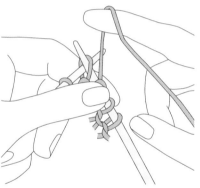

Fig. K6 purling English-style

KNITTING METHODS

There are a variety of ways to hold your yarn and knitting as you work.

Note: The two most common methods, English and Continental create stitches exactly the same way. The only difference is how the yarn is held.

combination knitting

A variation of Continental-style knitting. Yarn is wrapped the other way around for the purl stitch so that stitches are mounted left leg forward on the needle. Knit stitches are then worked through the back loop. It's faster, but has drawbacks: decreases lean the opposite way, and it only works for knitting stockinette stitch in rows, not for garter stitch, and not in the round.

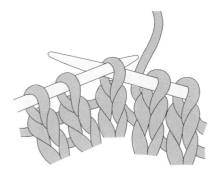
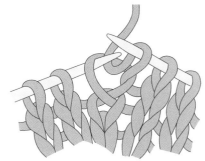

Fig. K7 knitting through the back loop

Continental-style knitting

The working yarn is held in the left hand. Most common in Europe. Many knitters find this method faster. (Figs. K3 and K4)

English-style knitting

Method of knitting with the working yarn held in the right hand. Most common in the United Kingdom and North America. (Figs. K5 and K6)

Portuguese knitting

A method of knitting, common in Portugal, where the yarn is tensioned either through a pin or around the neck. The yarn pulls from the front of the work toward the knitter, effectively, in purl position. Because of this, the purl stitch is significantly quicker and easier than the knit stitch, so Portuguese knitters work their garter stitch by purling every row.

KNITWISE

As if to knit, usually used in the context of slipping a stitch. To slip knitwise, put the needle into the stitch as if to work a knit stitch—from left to right—then slip the stitch to the right needle. This causes the stitch to be repositioned, so that the right leg of the stitch is at the back. In general, knitwise slips are only used in decreases.

KTBL

Knit through the back loop. (Fig. K7)

KWISE

Knitwise.

KYOK

See *increases*. See also *nupp*.

LC

Left cable. See *cables.*

LACE

Fabric with yarnovers used to create decorative holes. Decreases are used to create lines and keep the stitch count even. Most often, the wrong-side rows are worked plain, either all knits or all purls. Fagoting is a specific type of lace knitting where yarnovers and decreases are worked on both sides. (Fig. L1) See also *fagoting, fagot-stitch.*

LACE, LACEWEIGHT (YARN)

A thickness of yarn. See *yarn attributes, weights.*

LACE BIND-OFF

Also known as Russian lace or Estonian lace bind-off. Useful for lace and toe-up socks, projects that require significant extra stretch beyond the usual. The essence of the technique is this:

TECHNIQUE

Work 2 stitches, return them to the left needle, and then work them together. The most common version is to knit the stitches, return them to the left needle without twisting, and then knit them together through the back loop. This gives an edge that looks like the common bind-off, but is much stretchier. Purling the stitches instead of knitting them gives an even stretchier edge.

LADDERS

A column of loose stitches on a piece worked in the round. (Fig. L2) Ladders can happen in three places: at the start of a needle if you're working on dpn, at the start of a side if you're on Magic Loop/two circulars, or on any configuration if you've placed a particularly large stitch marker, and the yarn is catching on or around it.

Ladders happen because the yarn has to travel farther to work the first stitch of the needle (or

Fig. L1 lace

Fig. L2 ladders

after the marker) than between stitches that are immediately adjacent. That extra yarn is taken up into the first stitch of the needle, making it larger than the rest. Ladders are fairly common and are not a mistake in your knitting—just a natural by-product of working in the round on multiple needles.

LEFT-HAND, LEFT-HAND CARRY

This refers to knitting with the yarn tensioned or held in your left hand. Also known as Continental knitting. See also *knitting methods*.

LEFT-HAND SIDE

Sometimes used in instructions when referring to needles or the position of your work. For example, if you're looking at a piece of knitting lying on the table in front of you, the left-hand side is the side that's on your left. This is distinct from left side.

LEFT SIDE

When referring to a garment, the left side is the side that sits on the left side of your body. The left sleeve goes on your left arm. The left front of a cardigan goes on the side of your body closest to your left arm. It's always from the perspective of the wearer.

When you're knitting, this may seem the wrong way around. If you lay a sweater on a table in front of you, the left side is on the right. This is distinct from left-hand side. See also *right side*.

LH, LHS

Left-hand side.

LIFELINE

A lifeline is way to help prevent mistakes and make them easier to fix. It's most often used for lace knitting, but can be helpful in any kind of project.

Thread a length of smooth, fine, contrasting-color yarn through the stitches on the needle. Then keep knitting. If there's a problem with

the knitting, the work can be taken off the needles and undone ("frogging"). The stitches threaded onto the lifeline are safe and won't undo any further. Put the needle back into the work following the path of the lifeline and resume working.

If you're following a complicated pattern, write down in which row you threaded the lifeline so you know where to pick up again.

LIFTED INCREASE
See *increases*.

LINEN (FIBER/YARN)
Derived from the flax plant, this fiber is heavy, wrinkly, and stiff. It softens over time and is breathable. Excellent for summer garments. See also *fiber care*.

LIVE, LIVE STITCHES
Referring to stitches that are not bound off, that are still available to be worked. When working a project that requires you to hold live stitches, they must be slipped to a stitch holder on scrap yarn. See also *slip stitches to holder*.

LLAMA (FIBER/YARN)
Derived from the coat of a llama. It's a very soft and warm fiber, but delicate and pilly. Best for accessories that don't experience much friction, such as hats. See also *fiber care*.

LLI
See *increases*.

LONG-TAIL CAST-ON
This method, although a little tricky to master, is a fantastic all-purpose cast-on. The edge it

creates is attractive, flexible, and easy to seam and pick up stitches from. It uses one needle.

Note: There is great debate about whether you need to start with a slipknot or not. I prefer to, as it makes the first stitch more even with the rest of the row. It's also a bit easier to learn that way. If you don't want a slipknot, just drape the yarn over the needle before you set up the hold. (Fig. L3)

TECHNIQUE

Step one: Leaving a long tail (about 1–2" for each stitch to be cast on), make a slipknot and place on right needle. Place thumb and index finger of left hand between yarn ends so that working yarn is around index finger and tail end is around thumb. Secure ends with your other fingers and hold palm upward, making a V of yarn.

Step two: Bring needle up through loop on thumb, grab first strand around index finger with needle.

Step three: Go back down through loop on thumb.

Step four: Drop loop off thumb and, placing thumb back in V configuration, tighten resulting stitch on needle.

LT
Left twist. See *cables*.

LYS
Local yarn shop.

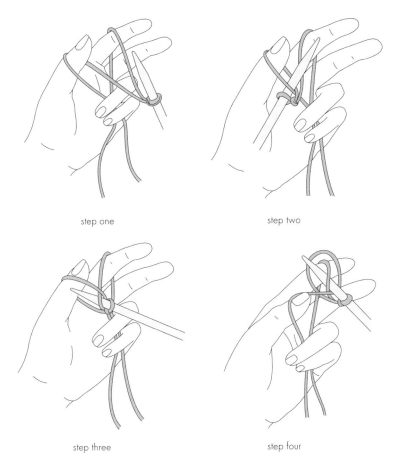

step one

step two

step three

step four

Fig. L3 long-tail cast-on

TIP

To make the edge stretchier, make sure you leave some space between the stitches on the needle. Don't crowd them. Using a larger needle or two needles held together doesn't help—all it does is make the loops of the stitches larger.

M
Marker or meter.

M1
See *increases.*

M1L/M1PL
See *increases.*

M1R/M1PR
See *increases.*

MAGIC LOOP
See *circular knitting.*

MAKE ONE
See *increases.*

MAINTAIN PATT
See *as est, as established, as set.*

MARKER, STITCH MARKER
A device to help you keep track of stitch counts and pattern placement. Closed ring-style markers are placed on the needle between stitches and stay in place until you're specifically told to remove them or you bind off. Removable markers can also be used to mark a position on finished fabric or aid in finishing or counting rows/rounds. (Fig. M1) See also *pm; rm; sm.*

MARLED
See *yarn attributes, color.*

MATERIALS
The section of pattern instructions that tells you the materials required to make the project shown. This can include both the yarn and notions needed. See also *notions.*

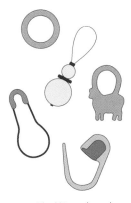

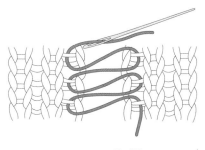

Fig. M1 stitch markers

Fig. M2 mattress stitch

MATTRESS STITCH

A seaming method for joining the vertical edges of two knit fabrics, worked by weaving yarn around the stitches at the edges. (Fig. M2) See also *seaming*.

TECHNIQUE

With RS of knitting facing, use threaded needle to pick up 1 bar between first 2 stitches on 1 piece, then corresponding bar plus the bar above it on other piece. *Pick up the next bar on first piece, then next bar on other. Repeat from * to end of seam, finishing by picking up last bar at the top of first piece. If the 2 pieces are slightly different lengths, you can ease them together by periodically picking up 2 bars in the longer piece.

MB

Make bobble.

MC

Main color. See *colorwork, color knitting.*

MEAS

Measure(s).

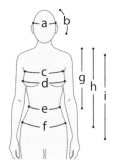

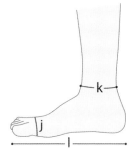

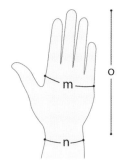

Fig. M3 hat & top measurements **Fig. M4** sock measurements **Fig. M5** mitten measurements

MEASUREMENTS, BODY

Referring to the illustrations provided, take your measurements to have on hand as you browse patterns. (Figs. M3–M5)

You'll need a friend to help you. Hands, feet, head, and arms should be bare. Hold the tape measure snugly; make sure there's no slack.

Some patterns may need other measurements, but these are the key ones. Remember: these likely won't be the finished measurements of the project you make. See also *ease*.

hat measurements

a. Circumference of head just above ears

b. Depth from crown of head to just under ears

sweater/top measurements

c. Upper bust circumference

d. Fullest part of bust circumference

e. Waist circumference

f. Hip circumference

g. Length, shoulder to natural waist

h. Length, shoulder to hip

i. Arm length from tip of shoulder to wrist

sock measurements

j. Foot circumference at ball of foot

k. Ankle circumference at narrowest part

l. Foot length from back of heel to tip of longest toe

mitten measurements

m. Circumference of palm of hand just above the thumb

n. Circumference of wrist

o. Length of hand, from tip of longest finger to wrist

MEASUREMENTS, FINISHED

This heading is used in a pattern to indicate the dimensions of the completed piece. Sometimes these are labeled as "Finished" or "Actual" measurements, but no matter the name, this is the size of the piece that you are knitting, as measured after blocking. See also *finished measurements; ease*.

MEMORY

Used to describe fiber that has the ability to remember or "hold" a stretch. Wool, for example, has excellent memory. If it's stretched out when wet, it will stay that shape once it's dry. Cotton, silk, alpaca, and other animal fibers also have memory. The more plies and the more twisted a yarn is, the stronger the memory is. See *elasticity; blocking*.

MERINO (FIBER/YARN)

A specific breed of sheep. Merino is considerably softer than wool from more generic sheep breeds. Can be processed in a way that allows it to be washed in the machine. It's excellent for a wide variety of projects. See also *fiber care; superwash wool*.

METER

A length measurement; 1 meter equals 100 cm, which equals 1.1 yards. Often used for indicating the length of yarn in a ball or skein. See also *metric conversions*.

METRIC CONVERSIONS

The formula to change imperial measurements to metric, both for length and weight. To convert inches to centimeters, take the number of inches and multiply it by 2.54. To convert centimeters to inches, take the number of centimeters and multiply it by 0.4.

EXAMPLE

1 inch = 2.54 cm

1 cm = 0.4 inches

1 yard = 36 inches = .91 meters

1 meter = 39 inches = 1.1 yards

1 oz = 28 g	50 g = 1.75 oz
2 oz = 56 g	100 g = 3.5 oz
4 oz = 112 g	

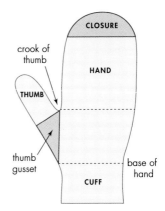

Fig. M6 mitten anatomy

Labels: CLOSURE, crook of thumb, HAND, THUMB, thumb gusset, CUFF, base of hand

MITT, MITTEN

A hand covering, with a single section for the upper hand and fingers. A fingerless mitten is open at the top. (Fig. M6)

Most often worked in the round, it's typically knitted from the cuff up. The thumb can be constructed two ways: with increases to create a gusset or with a simple split opening. A vertical slit is often used for a simple fingerless mitten. A gusseted thumb conforms better to the shape of the hand and therefore can be worn more fitted and looks a little more sophisticated. A "peasant" thumb is often used for colorwork mittens. To keep the design simpler, the hand is worked as an unshaped tube, and the thumb is made over a horizontal slit on the palm side.

For warmth, it's best to wear a closed mitten with a little positive ease; fingerless mittens are better worn with a little negative ease.

MM

Millimeter(s). Knitting needles often have a millimeter size provided. See also *needle sizes*.

MOCK TURTLENECK, MOCKNECK

See *necklines and collars*.

MODAL (FIBER/YARN)

A type of rayon made from beech trees. See *rayon; fiber care*.

MODIFIED DROP SHOULDER

A style of garment—can be a pullover or a cardigan—very closely related to the Drop Shoulder. See *sweater types*.

MODULAR KNITTING

A method of constructing larger knitted pieces by working smaller, distinct pieces, joined as you work, either through picked-up stitches or casting on new stitches and working decreases, in the style of an attached edging. A log cabin blanket is a classic example.

MOHAIR (FIBER/YARN)

Fiber derived from the coat of Angora goats. This fuzzy fiber is very light, strong, and warm, but lower-quality mohair can feel rough or scratchy. Look for "superfine kid" or "kid" mohair. Takes dye very well. Excellent for winter accessories on its own or in blends. A fine strand of mohair carried alongside another yarn adds warmth and insulation to a fabric without adding thickness. See also *fiber care*.

MOSAIC

Another name for slip-stitch colorwork. See *slip-stitch colorwork*.

Fig. M7 moss stitch sample

MOSS STITCH

In the United Kingdom, this is known as double moss stitch. As with seed stitch, it's reversible, and can be worked on any number of stitches, although the instructions change depending on whether you have an even or odd number of stitches. The fabric lies flat, making it good for pieces such as scarves and blankets. You work two rows of lined-up knits and purls and then offset the stitches for two rows. (Fig. M7)

worked flat, in rows, over an even number of stitches

Rows 1 and 2: (K1, p1) across.

Rows 3 and 4: (P1, K1) across.

worked flat, in rows, over an odd number of stitches

Rows 1 and 2: (K1, p1) to last stitch, k1.

Rows 3 and 4: (P1, k1) to last stitch, p1.

worked in the round

Requires an even number of stitches.

Rounds 1 and 2: [K1, p1] around.

Rounds 3 and 4: [P1, k1] around.

MOTIF

The graphic elements that make up a design. The stitch pattern in stranded colorwork is often called a motif, for example.

MULT, MULTIPLE

In the context of pattern stitches, indicating how many stitches are needed to work a pattern stitch. For instance, (k2, p2) ribbing requires 4, 8, 12, 16, . . . stitches for the pattern to work out. That is, you need a total number of stitches that divides evenly by four.

You might also see a note that a pattern stitch requires a multiple of a certain number of stitches, "plus" more, e.g., "a multiple of 4 stitches plus 2."

This means that to make the instructions work out, you need not an exact multiple, but some extra.

EXAMPLE

Row 1: (RS) K2, (p2, k2) to end.

A repeat of this pattern requires 6, 10, 14, … stitches; in short, a multiple of four stitches plus two.

NATURAL (COLOR YARN)

See *yarn attributes, color*.

NECKBAND

Refers to the finished edge of a neckline. Stitches are usually picked up along a bind-off edge to give a cleaner finished look.

NECKLINES AND COLLARS

See Fig. N1 for examples of necklines and collars.

necklines

boatneck

Most common for pullovers, a style of neckline that's wide and high—close to the actual neck. Funnel necks and cowl collars are built on top of boatnecks.

cowl-neck

A tall collar, usually worn folded, based on a rounded neckline (but more open than a crew neck) or a boatneck.

crew neck

A shallow edging worked on top of a round neck.

funnel neck

Built on a boatneck, a short but wide extension of the neckline.

henley

A variant of the crew neck, with a central split. The edging around the neck is shallow, and at the split the edgings on the two sides may overlap, possibly with a button for closure, or they may meet with a zipper for closure.

scoop neck

A deeply curved wide neckline.

square neck

More of a half square than a full square, this neckline frames the collarbones.

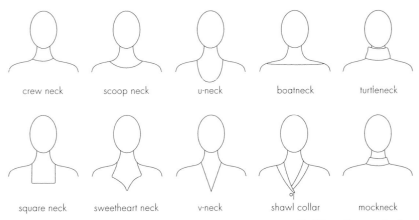

| crew neck | scoop neck | u-neck | boatneck | turtleneck |

| square neck | sweetheart neck | v-neck | shawl collar | mockneck |

Fig. N1 necklines and collars

sweetheart neck

Considered a feminine neckline, the edges of a deep V are scalloped to follow the shape of the bust.

u-neck

This neckline has depths similar to a V-neck, but with a more gentle curve to the base.

v-neck

A neckline style in the shape of a V, constructed as a straight slope between the shoulder and the base of the neck opening.

collars

mockneck, mock turtleneck

Built on a round neck, a medium-tall collar that sits close to the neck, ending partway up the wearer's actual neck.

tutleneck

A high, close-fitting collar that is turned over.

shawl collar

A rounded collar with enough width to fold over around the neckline. It extends down the front of the garment.

NEEDLE GAUGE

Tool for measuring the size of a needle.

NEEDLES

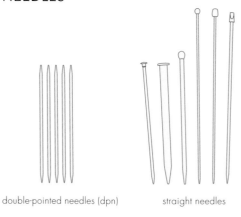
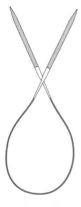

double-pointed needles (dpn) straight needles circular needle (circ)

NEEDLE SIZES

METRIC	US	UK
1.5 mm, 1.75 mm	000, 00	No equivalent
2 mm	0	14
2.25 mm	1	13
2.5 mm	No equivalent, sometimes #1.5	No equivalent
2.75 mm	2	12
3 mm	No equivalent, sometimes #2.5	11
3.25 mm	3	10
3.5 mm	4	No equivalent
3.75 mm	5	9
4 mm	6	8
4.25 mm	No equivalent	No equivalent
4.5 mm	7	7
5 mm	8	6

METRIC	US	UK
5.5 mm	9	5
6 mm	10	4
6.5 mm	10.5	3
7 mm	No equivalent, sometimes #10.75	2
7.5 mm	No equivalent	1
8 mm	11	0
9 mm	13	00
10 mm	No equivalent	000
11 mm	15	No equivalent
12 mm	17	No equivalent
15 mm	19	No equivalent
20 mm	35	No equivalent
25 mm	No equivalent	No equivalent
50 mm	50	No equivalent

Fig. N2 Norwegian louse sweater

NEGATIVE EASE

See *ease*.

NO STITCH

Often seen in charts with increases and decreases. Due to the grid structure of charts, if stitches are decreased, a special no-stitch symbol (often a gray box) may be placed in the chart where the stitch used to be. This can help to keep the pattern aligned in the chart diagram, for ease of reading and following. It's just a spacer for the layout, ignore it when reading and working from the chart. See also *charts*.

NORWEGIAN "LICE" OR "LOUSE" SWEATER

A traditional design featuring a simple and bold two-color stranded-colorwork pattern that is named for its resemblance to the tiny insect. (Fig. N2)

NOTIONS

The bits and bobs needed to aid in knitting a project. These include tapestry needle, stitch markers, scissors, and tape measure. A notions bag is a handy tool as well to keep these items together. The term "notions" can also refer to buttons and zippers.

NOVELTY YARNS

A loose category of yarns, roughly any yarn that isn't a simple twist of one or more fiber strands. Ribbon, fur, chenille, and other highly textured yarns are often described this way. See also *yarn attributes, textures*.

NUPP

The Estonian term for bobble. Typically, a nupp is on the larger side and worked over two rows. On the first row, one stitch is increased to seven or nine stitches, and then it's decreased back down to one on the following row. See also *bobble*.

NYLON

Made from coal, this is a strong fiber that is sometimes blended with other fibers to add strength and resilience to a yarn. Sock yarn often has a nylon component, between 5 and 25%, usually.

OPENWORK

Any fabric that has deliberately placed holes. Often lace, but not always. Holes can be created through dropped stitches, binding off and casting on, short-row turns, etc.

OUNCE, OZ

A unit of weight in the metric system, equivalent to 28 grams. Commonly used as measurement for yarn ball or skein quantities.

OVER

As in "work over __ stitches." This tells you that you're going to work a given stitch pattern across a specific number of stitches.

EXAMPLE

Work (k1, p1) over 20 stitches, work row 1 of lace chart to end.

"Over" is also used in combination with "yarn" in the term "yarnover." In which case the yarn is wrapped over the needle to create a new stitch. See also *yo*.

P
Purl.

P2TOG, P3TOG, . . .
See *decreases*.

P2TOG TBL, P3TOG TBL, . . .
See *decreases*.

PARENTHESES ()
See *brackets []*.

PASS OVER, PASS STITCH(ES) OVER
To lift stitch(es) over the neighboring stitch and off the needle, as for binding off. Sometimes it's one stitch, sometimes two. This is also common in lace and textural patterns. See also *psso; bind-off*.

PATT(S)
Pattern(s).

PFB, P1F&B
See *increases*.

PICKING UP STITCHES; PICK UP; PICK UP AND KNIT
To use a knitting needle to grab loops/strands along the edge of a piece of knitting to create new stitches. The terms "pick up" and "pick up and knit" are sometimes used interchangeably, which is not entirely accurate. To be precise, when we say to pick up stitches, we mean to use a knitting needle to grab loops/strands along the edge of a piece of knitting. In other words, you're threading the needle through the edge of the work. Most times, if a pattern asks the knitter to pick up stitches, you can assume it means to pick up and knit them.

To pick up and knit, you poke the needle from front to back through the edge of the fabric, wrap the working yarn around the tip of the needle, and pull it through as if you're

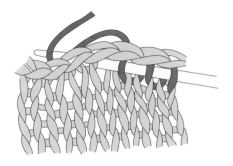

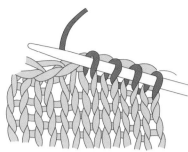

Fig. P1 pick up and knit

knitting. You hold the needle in your right hand, and work from right to left. (Fig. P1)

Pick up and purl is also possible. For that, put the needle through from back to front, wrap yarn, and complete the stitch like a purl.

where to pick up stitches and how many

- **If you're working along a cast-on or bind-off edge,** pick up one stitch for every one in the edge, working under the lip of the edge, into the center of the stitches.

- **If you're working along the side edge,** poke the needle into the gaps in the column between the edge stitch and its neighbor. In this case, because you're picking up perpendicularly to the direction the knitting was worked—that is, you're picking up stitches over rows—you need to take into account the difference between stitch and row gauge. A pattern might tell you the ratio of stitches to rows to pick up—it's often two stitches for three rows or three stitches for four rows. Or it might tell you a specific number. It's helpful to use removable stitch

markers or safety pins to divide the edge into quarters and be sure to evenly distribute the stitches through each section.

- **If you are picking up along a curved edge,** it's usually safe to use the 3-in-4 ratio, unless the pattern tells you otherwise. Be consistent about the position of the picked-up stitch relative to the edge: if you're working between the edge stitch and its immediate neighbor, as much as possible work in that column all along the edge; and avoid big holes. If there's a larger-than-normal hole (often created by bind-off or cast-on steps), don't pick up in the hole. It will stretch out and get larger. Pick up as close as you can on both sides of the hole, and this will close the hole. It's better to pick up stitches in a tight space than a loose one.

TIP

If you find picking up challenging (with a knit or not), use a smaller needle than the size used for knitting or a crochet hook.

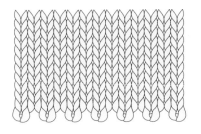
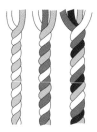

Fig. P2 picot edge

Fig. P3 2-ply, 3-ply, and 4-ply yarns

Fig. P4 pom-pom

PICOT EDGE

Generally, a small decorative loop, knot, or twist. A picot edge has picots distributed along it. You can create picots as part of a cast-on or bind-off, or add them later, typically with crochet. (Fig. P2)

PLACE STITCHES ON HOLD

Many garments worked seamlessly require that live stitches be put onto waste yarn or other stitch holder while another area of the garment is worked—usually sleeve stitches on a top-down sweater. At a later stage of the pattern, these stitches will be returned to the working needles and knit. See also *slip stitches to a holder.*

PLY, PLIES

The strands that twist together to create yarn. A yarn can be made up of a single twisted strand of fiber or multiple strands of fiber twisted together. In the United Kingdom, Australia, and New Zealand, "ply" is sometimes used to denote yarn thickness.

"Single" is sometimes used to describe a yarn that only has one ply. A 2-ply yarn has two strands, a 3-ply has three strands, and so forth.

A plied yarn tends to wear better than a single: the more plies and the tighter the twist, the less likely the yarn is to pill and wear away. (Fig. P3)

PM

Place marker. Used in an instruction to indicate that a marker should be placed on the needle, between stitches, at a specific point.

POLAR

A thickness of yarn. See *yarn attributes, weights.*

POLYAMIDE (FIBER/YARN)

A synonym for nylon. See *nylon*. See also *fiber care.*

POM-POM, POMPOM, POMPON

A decorative tufted ball of yarn. You can buy special tools to make them, but two rings of sturdy cardboard work just as well. (Fig. P4)

PORTUGUESE METHOD

See *knitting methods.*

POSITIVE EASE

See *ease.*

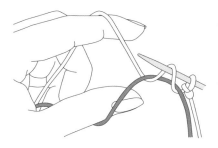
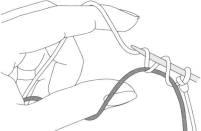

POSSUM (FIBER/YARN)

Fiber derived from the animal native to Australia. Very warm and soft, but can be pilly. Terrific in blends to add softness and warmth, but it is not a strong fiber on its own. See also *fiber care*.

PREV

Previous, previously.

PROVISIONAL CAST-ON

A cast-on worked so that the lower edge of the fabric can easily be removed to create live stitches at the cast-on edge. You might do this for a cowl or circular scarf, so that you can work a three-needle bind-off or grafted join. There are a number of provisional cast-ons, shown here is one method.

TECHNIQUE

Place a loose slipknot on needle held in your right hand. Hold waste yarn next to slipknot and around left thumb; hold working yarn over left index finger.

Step 1: *Bring needle forward under waste yarn, over working yarn, grab a loop of working yarn.

Step 2: Then bring needle to the front, over both yarns, and grab a second loop.

Repeat from *. When you're ready to use the cast-on stitches, pick out waste yarn to expose live stitches. (Fig. P5)

See also *live, live stitches*.

PSSO

Pass slipped stitch(es) over. See *bind-off; pass over.*

PUK

Pick up and knit.

PURL

A fundamental stitch, worked exactly the opposite way to the knit stitch.

To work a purl, hold the working yarn in front. Put the tip of the right needle into the front leg of the first stitch on the left needle from right to left; wrap the yarn around the tip of the right needle, from right to left, over the tip and back around to the front. Take this strand back through the stitch on the left needle and let the stitch slip off the left needle so that the new stitch sits on the right needle.

The direction that the needle tip is inserted into the stitch and the direction of the yarn wrap are important. The resulting stitches are mounted so that the right leg of the stitch is always at the front of the needle.

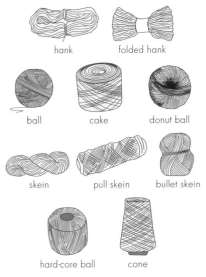

hank folded hank

ball cake donut ball

skein pull skein bullet skein

hard-core ball cone

Fig. P6 put-ups

PURLWISE

As if to purl. Used when the pattern requires slipping a stitch or threading a yarn needle through stitches from right to left. Slipping a stitch purlwise preserves the stitch orientation (mount). If the instruction does not specify and it is not part of a decrease, you can safely assume the stitch is to be slipped purlwise.

PUT-UP

How yarn is packaged: the size and the shape. It can be a ball or a skein; it might be 2 ounces, 50 grams, 100 grams, 4 ounces, etc. (Fig. P6) See also *ball; skein*.

PTBL

Purl through the back loop. See *back loop*.

PWISE

Purlwise.

QIVUIT/QIVIUK (FIBER/YARN)

Derived from the coat of a musk ox. Very warm and soft, but can be pilly. Since it is difficult to gather and from a rare animal, it is very expensive. Look for it in blends to add softness and warmth. See also *fiber care*.

RAGLAN

See *sweater types*.

RAVEL

See *unravel*.

RAVELRY

Popular online hub for those who love yarn and fiber.

RAYON (FIBER/YARN)

A highly processed fiber derived from plants. It has a similar sheen and hand to silk, but it is heavy and fragile when wet. See also *fiber care*.

RC

Right cross. See *cable*.

REM, REMS, REMAINS

Remain(ing)(s), usually used in the context of how many stitches you have remaining. When working a pattern, consider it a cue to stop and count your stitches to make sure you're on track before you proceed.

REP, REPEAT, REPEATS

Indicates a section of instructions to repeat or how many repeats of a pattern you already should have done. Patterns use some sort of bracketing *, [], or () to indicate which part to repeat.

"Repeat" is used in the context of a pattern stitch instruction to indicate that the pattern comprises the same stitches worked over and over again. A row that is the same two stitches worked over and over again, e.g., (k1, p1) ribbing, is a two-stitch repeat.

EXAMPLE

Instead of

Row 1: K2, p2, k2, p2, k2, p2, k2, p2, k2, p2 k2, p2.

The pattern says:

Row 1: *K2, p2; repeat from * 5 more times.

In this case, the * marks the start of the phrase to be repeated.

Fig. R1 reverse stockinette stitch

Fig. R2 1×1 ribbing

You can also have a row repeat: a pattern made up of multiple rows of instructions.

EXAMPLE

Moss Stitch

Row 1: (RS) (K1, p1) to end.

Row 2: (WS) (K1, p1) to end.

Row 3: (P1, k1) across.

Row 4: (P1, k1) across.

This is a two-stitch, four-row repeat. It requires two (or any multiple of two) stitches, and four (or any multiple of four) rows to be complete.

REVERSE STOCKINETTE STITCH, REVERSE STOCKING STITCH, REV ST ST

The "purl side" of stockinette stitch. (Fig. R1) The fabric doesn't lie flat, it tends to roll up. See also *stockinette stitch*.

REVERSING SHAPINGS

A term used in patterns that means you should take shaping instructions for one side and knit their mirror image for the other side. Although less common in digitally published patterns, this phrase used to be standard in printed garment patterns as a way to save space. For example, for the left and right fronts of a cardigan, the pattern would have instructions for one side in detail, and for the second side, only "Work as for first, reversing shapings."

Read ahead through your pattern to see if this key phrase is there. If so, when you work through the first piece, keep notes on what to do where. For example, if it's cardigan fronts, you will be given instructions for how to decrease for the left front armhole, at the start of the RS row—therefore for the other side, you'll do it at the end of the RS row.

RH, RHS

Right-hand, right-hand side.

RIBBING

Ribbing patterns are combinations of knits and purls, worked in columns. Ribbing based fabrics are reversible, and although they tend to pull in, they do lie flat, making them good for scarves and garment edgings.

Fig. R3 2x2 ribbing

1x1 ribbing *(Fig R2)*

worked flat, in rows,
over an even number of stitches

All rows: (K1, p1) across.

worked flat, in rows,
over an odd number of stitches

Row 1: (K1, p1) to last st, k1.

Row 2: (P1, k1) to last st, p1.

worked in the round,
over an even number of stitches

All rounds: (K1, p1) around.

2x2 ribbing *(Fig R3)*

worked flat, in rows,
over a multiple of 4 stitches

All rows: (K2, p2) across.

worked flat, in rows,
over a multiple of 4 stitches plus 2

Row 1: (K2, p2) to last 2 sts, k2.

Row 2: (P2, k2) to last 2 sts, p2.

worked in the round,
Over an even number of stitches

All rounds: (K2, p2) around.

RIBBON

See *yarn attributes, textures.*

RIGHT-HAND, RIGHT-HAND SIDE

Sometimes used in instructions when referring
to needles or the position of your work.
For example, if you're looking at a piece of
knitting lying on the table in front of you, the
right-hand side is the side that's on your right.
This is distinct from "right side."

RIGHT-HAND CARRY

This refers to knitting with the yarn tensioned
or held in your right hand. Also known as
English knitting. See also *knitting methods.*

RIGHT SIDE

The side of a knitted piece that is to be shown
on the outside is considered the "right side";
the other side is the "wrong side." Sometimes
referred to as the "public" side of your work.

Pattern instructions will indicate RS and WS in rows as a way to guide you and keep you on track.

In the context of garment knitting, the right side is the side that sits on the right side of the body. The right sleeve goes on your right arm. The right front of a cardigan goes on the side of your body closest to your right arm. It's always from the perspective of the wearer.

When you're knitting, this may see the wrong way around. If you lay a sweater on a table in front of you, the right side is on the left.

This is distinct from right-hand side.

See also *left side*.

RLI
See *increases*.

RM
Remove marker.

RND(S), ROUND
When you are working circular knitting, you are working in rounds, not rows. "Working in the round" is another phrase for "circular knitting." See also *circular knitting*.

ROW
When you work flat across all the stitches on your needle, you have worked a row. To count rows, count the stitches that sit below the needle and don't count the loops on the needle. Because of the way garter-stitch fabric compresses, we count ridges instead of rows. One ridge is two rows. See also *garter stitch; stockinette stitch*.

ROW COUNTER
A small tool to help you keep track of the rows or rounds completed. Advance the counter at the end of each row to keep count.

ROW GAUGE
Your vertical gauge—typically measured in patterns as the number of rows in 4" (10 cm). See also *gauge*.

ROWING OUT
This is the term for what happens if your gauge is significantly different for your knit and purl stitches. It affects stockinette-stitch fabrics, since the rows that are purled will be looser and larger than the knit rows. It's most obvious on the WS of your work—you'll have two purl ridges close together separated by larger gaps.

To address this, you can work with two different size needles, using a smaller needle for the purl rows. A set of interchangeable circular needles allows you to have one tip smaller than the other.

RS, RIGHT SIDE
Short for "right side," always in the context of the public side, the outside, of your knitted fabric. See also *right side*.

RT
Right twist. See *cable*.

RUSSIAN LACE BIND-OFF
See *lace bind-off*.

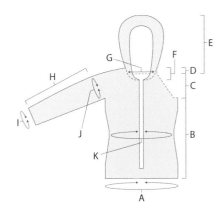

Fig. S1 *sample schematic*

S-TWIST
When the direction of twist is to the left in spun and plied yarns, it's called S-twist.

S2KP
See *decrease.*

SABLE
Stash acquisition beyond life expectancy; common in online parlance, a way to express that you have more yarn than you could reasonably expect to knit up over your lifetime.

SADDLE SHOULDER
See *sweater types.*

SCHEMATIC
This is a diagram of the pieces created when knitting a pattern, with detailed measurements. Use the schematic to get a sense of the details of the shape and size of a finished piece, things you can't always tell from photographs. See also *finished measurements.*

- Some publishers and/or designers will use letters that correspond to a list of measurements. (Fig. S1) Others will provide the numbers directly on the schematic.

- The numbers are of the finished measurements of the pieces. If it says that the sleeve of the smallest size is 12" (12.5 cm) long from the underarm and if you work the smallest size, knitting to gauge, your sleeve with be 12" long.

- If the pattern offers multiple sizes, the schematic will show this. If there's only one number for a particular dimension, it means it applies to all of the sizes.

- It's not a mix-and-match thing: the first numbers on all measurements apply to the first size only; the second number applies to the second size only, and so forth.

SCOOP NECK
See *necklines and collars.*

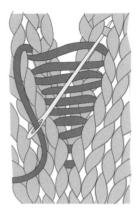

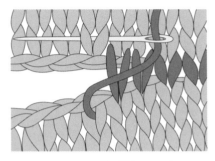

Fig. S2 vertical seaming

Fig. S3 horizontal seaming

SEAMING

Sewing up knit pieces, usually by hand. Knit fabrics are typically seamed with wrong sides held together (unlike woven fabrics, which are usually sewn with the right sides held together). Seams are worked by weaving yarn around the stitches on both edges.

There are three different methods, depending on the orientation of the fabrics: both vertical (i.e., side edge to side edge), both horizontal (i.e., cast-on or bound-off edges together), or one vertical and one horizontal (most used when seaming a sleeve to the body of the sweater).

You should always wash/block pieces before you sew them. See *blocking*. See also *three-needle bind-off*; *Kitchener stitch/grafting*.

vertical seam/mattress stitch

Joining two pieces edge to edge with a seam running vertically is best accomplished with mattress stitch. (Fig. S2) See also *mattress stitch*.

horizontal seam

When joining two edges horizontally, row to row, the seam is worked under the stitches. (Fig. S3) If a provisional cast-on is used, live stitches may be grafted to the last row of live stitches with Kitchener stitch. See also *Kitchener stitch/grafting*.

vertical to horizontal seam

This method combines the mattress stitch method of picking up the bars between stitches on the vertical edge and working under stitches along the horizontal seam. (Fig. S4) Because stitches aren't square (they are wider than they are tall), you need to apply an easing to the seam. Typically, you need to work four bars (rows) for every three stitches.

For these types of seams, it's very helpful to use removable stitch markers, safety pins, or clips to align the edges and determine the easing required.

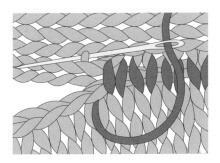

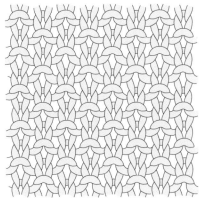

Fig. S4 vertical to horizontal seam

Fig. S5 seed stitch

SECURE ENDS

See *weave in ends.*

SEED STITCH

A common stitch pattern that involves deliberately working the opposite of each stitch, purling the knits and knitting the purls. In the United Kingdom, this is known as moss stitch. It's reversible and can be worked on any number of stitches, although the instructions change depending on whether you have an even or odd number of stitches. The fabric lies flat, making it good for pieces such as scarves and blankets. (Fig. S5)

worked flat, in rows,
over an even number of stitches

Row 1: (K1, p1) across.

Row 2: (P1, K1) across.

worked flat, in rows,
over an odd number of stitches

All rows: (K1, p1) to last stitch, k1.

worked in the round,
over an even number of stitches

Round 1: [K1, p1] around.

Round 2: [P1, k1] around.

worked in the round,
over an odd number of stitches

All stitches: [K1, p1] around.

SELF-STRIPING

See *yarn attributes, color.*

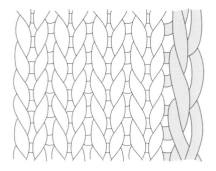

Fig. S6 slip-stitch selvedge

• On stockinette stitch, slip the first stitch of every row purlwise, with yarn held to the wrong side of the fabric.

• On garter stitch, slip the first stitch of every row purlwise, with yarn held to the front, as if you were going to purl; before you knit the next stitch, take the yarn to the back to knit position.

SELV, SELVAGE, SELVEDGE

An edge treatment. In knitting, this usually refers to a stitch or two on the edges of the fabric that are worked in a particular manner to create a seam allowance or a decorative effect.

One common instruction is to slip the first stitch of every row to create a selvedge. (Fig. S6) This has a nice effect for a scarf or a piece where the edges are visible and won't be seamed. For garter stitch, it removes the bumpiness of the edge.

In general, only slip a stitch at the edge if the pattern explicitly tells you to. It's not helpful if the pieces are going to be seamed, as it will make the edge and join sloppier.

SEMICOLON ;

Often used in pattern instructions as part of a repeat, typically to indicate the end of an instruction that is to be repeated. See *repeat*.

SEMISOLID, SOLID

See *yarn attributes, color*.

SET

As in "in pattern as set." See *as est, as established, as set*.

SET-IN SLEEVE

See *sweater types*.

SEWN BIND-OFF

This method, popularized by Elizabeth Zimmermann, forms a very elastic edge that has a ropy appearance, much like a purl row. Work this bind-off with a yarn needle. Cut the yarn three times the width of the knitting to be bound off and thread onto a yarn needle.

TECHNIQUE

Working from right to left, *insert yarn needle purlwise (from right to left) through first 2 stitches and pull the yarn through, then bring needle knitwise (from left to right) through the first stitch, pull the yarn through, and slip this stitch off the knitting needle. Repeat from *. (Fig. S7)

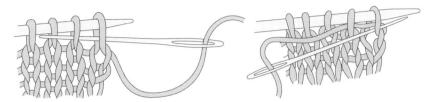

SHAWL COLLAR

See *necklines and collars.*

SHORT-ROWS

When you work partway across the row (or round) and turn back to work the other side before reaching the end. The next time you work the full row, past the turning point, there will be a small hole in the fabric created by the turn, unless you apply one of the number of techniques to close it up: wrap and turn, Japanese short-rows, German short-rows, yarnover methods, and others. Although the precise details differ, each of these involves two steps: a wrap of yarn or extra stitch created when you turn and then a step to pick up the wrap or extra stitch that closes up the gap. These methods are interchangeable in that they all accomplish the goal of closing up the gap.

SHORT-ROW HEEL

A short-row heel is sometimes called a "boomerang heel" because of the way it's worked. Using short-row turns, you work back and forth on the heel stitches, working one stitch fewer every row until about a third of the heel stitches remain in the center. You then work back out, working one stitch more every row, until you're back working across the full width of the heel.

SILK (FIBER/YARN)

Derived from the cocoons of silkworms. It is strong and lustrous and very warm. It stretches over time, so it's better for smaller pieces or garments with seams. Works well blended with more stable fibers; sometimes used in sock yarns as an alternative to nylon. See also *fiber care.*

SINGLE PLY

A yarn made from a single strand of fiber, twisted on itself. Sometimes referred to as a "single," these yarns are generally more delicate, prone to pilling and wear. See also *ply.*

SIZE

A pattern may or may not list a "size." This might be articulated as a letter, e.g., S, M, L; for kids' patterns it's often given as ages, e.g., "6 months, 12 months, 18 months." Some patterns list a chest/bust measurement for size. In all cases, this gives a sense of who the garment is to fit. In fact, some patterns actually label this as "To Fit."

Think of this as what you'd see written on the label inside commercially made clothes: it's a rough indicator of the relative bigness or smallness of the piece, but it doesn't say a lot about the finished measurements of the piece, or how it fits. Think about a T-shirt: even for adults, the dimensions and fit of a size Small vary wildly depending on where you buy it. Even if there are actual numbers or body measurements here, these aren't about the knitted piece—like men's suit sizes, they are the measurements of the person who is supposed to wear it.

For accessories and babies' and small children's garments, you can usually safely use it as a guide for what size to make; for adult garments, it's no more than a label and shouldn't factor into your decision about what size to make.

how to determine which size to make

Look for guidance in the pattern on choosing which size to make. It might be phrased in terms of ease, e.g., "choose a size with 2" (5 cm) of positive ease." It might be phrased in terms of the measurements, e.g., "choose the size closest to your own measurements." or "finished sock should be about an inch smaller around than your foot."

The fit recommendation is key: if it's there, you're in great shape! If it's not there, the photos can definitely help. Is the model wearing it tight or loose? It is hugging her curves or being worn over another garment jacket-style? Sometimes, you might be told how the model is wearing it in the photographs, e.g., "model is wearing size S with 2" (5 cm) of positive ease," or "model is wearing sweater with 42" finished bust measurement, her bust measurement is 38"." If the pattern tells you what size the model is wearing without any indication of ease or a statement about the model's measurements, then it's not actually helpful.

You can also "virtually" try the garment on: hold the tape measure around your torso, at the various bust/chest measurements, and see which seems to be best on you.

For busty women: be careful! You'll get a much better fit if you take your upper bust measurement instead of your full bust measurement and consider ease relative to that—just make sure you choose a style that accommodates your curves, such as a V-neck or a cardigan. If you've got 4" (10 cm) of ease around the fullest part of your bust, imagine how much ease that provides around your upper bust and lower torso.

See also *ease; measurements, body; measurements, finished.*

SK2P

See *decrease.*

SKEIN

Yarn packaged in a long loop, essentially the way the yarn comes off the spinning wheel. Most skeins weigh 100–115 g (3.5–4 oz), but you sometimes see 50–58 g (1.75–2 oz) sizes. A skein is usually twisted up for storage and

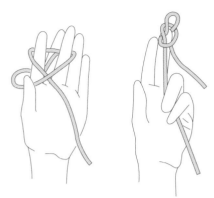
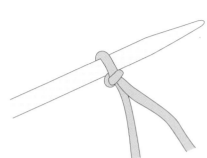

Fig. S8 a completed slipknot on a needle

must be wound into a ball before you can knit from it. See also *put-up.*

SKP

See *decrease.*

SLEEVE CAP

The top of the sleeve, the portion that is attached to the body.

SL1YO

See *brioche.*

SL, SLIP

Slip a stitch. Move the stitch to the right needle from the left, without pulling the yarn through it.

Stitches can be slipped knitwise or purlwise. In general, they should be slipped purlwise unless otherwise stated. Stitches in a decrease are traditionally always slipped knitwise. Some knitters do prefer to slip the second slipped stitch of the ssk purlwise as they feel that

improves the look of the resulting stitch. See also *knitwise; purlwise.*

SLIPKNOT

A knot with an adjustable loop that tightens up easily once you place it on the needle. (Fig. S8)

A slipknot is how many cast-ons are started. Some, such as the knit-on and cable methods, absolutely need it. For others, including the long-tail, the slipknot is optional, and knitters have very strong feelings about whether it should be used. It's personal preference. I like to start my long-tail cast-ons with the slipknot because it makes a stable first stitch that's easier to set up, and the slipknot looks more like a complete stitch, making the edge straighter. It's particularly helpful when casting on for working in the round, as it reduces the misalignment and divoting at the join. See also *cast-on.*

Fig. S9 single-color slip-stitch

Fig. S10 slip-stitch colorwork

SLIP-STITCH KNITTING

A way to create textural and colorwork patterns in knitting where not all stitches are worked in every row; some are simply slipped from one needle to the next.

single-color slip-stitch

When slip-stitch knitting with a single color, yarn is held either in front of the work (wyf) or in back of the work (wyb) to create the desired effect. Slip-stitch heels are common in socks as a way to reinforce the fabric. (Fig. S9) See also *flap-and-turn heel.*

slip-stitch colorwork

Also known as mosaic knitting. A way to create colorwork patterns by working only one color at a time, which means it takes two passes to work a two-color row/round. On the first pass, you work the color A stitches and slip the rest. On the second pass, you slip the color A stitches and knit the color B stitches. Although the finished fabric looks the same as stranded colorwork, the limitations are

different: you don't need to worry about the length of floats, so sections of color can be wider, but the fabric tends to pucker vertically. (Fig. S10) See also *colorwork, color knitting.*

SLIP STITCHES TO A HOLDER

Some patterns require you to slip stitches to a holder to set them aside for later use. In this case, whether using a stitch holder or scrap yarn, the tip of the holder goes into the stitches purlwise so that they are not repositioned or twisted.

If you're using scrap yarn, make sure it's a smooth yarn, not too fuzzy or textured, and in a contrasting color to the one you're knitting with. Cotton is terrific for this. Thread it onto a yarn needle and pull the needle through the stitches, from right to left, and let the stitches slip onto the yarn.

To return the held stitches to the needle for working, follow the path of the holder, inserting the tip of the needle purlwise. See also *place stitch on hold; stitch holder.*

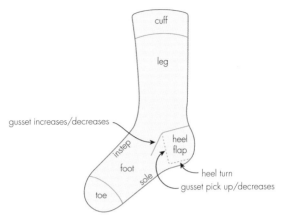

cuff

leg

gusset increases/decreases

instep

heel
flap

foot

sole

heel turn

gusset pick up/decreases

toe

Fig. S11 sock anatomy

SLUBBY

See *yarn attributes, textures.*

SM

Slip marker. Move the marker from the left to the right needle. The instruction isn't always explicitly given. Unless otherwise stated in the pattern, always slip a marker when you come to it on the needle.

SMOOTH (YARN)

See *yarn attributes, textures.*

SOCK ANATOMY

Almost always worked in the round, from the toe up to cuff or from the cuff down to toe. (Fig. S11) Gusset stitches are worked with increases or decreases depending on the direction the sock is worked. Socks should be smaller than the foot so that they stretch to fit: about 10% negative ease in foot circumference, 5% in foot length is best. The flap and gusset heel provides a good fit for most adult feet.

SOCK BLOCKERS

See *blocking tools.*

SPECKLED (YARN)

See *yarn attributes, color.*

SPLICE; SPIT-SPLICE

A way to join two ends of yarn by intermingling the plies or fibers of the yarn ends. See also *joining yarn.*

SPORT, SPORTWEIGHT

A thickness of yarn. See *yarn attributes, weights.*

SQUARE NECK

See *necklines and collars.*

SSK

See *decrease.*

SSP

See *decrease.*

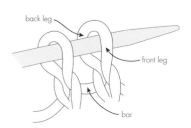

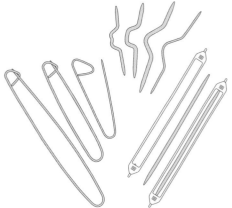

Fig. S12 knit-stitch anatomy **Fig. S13** saftey-pin-style and double-ended stitch holders

STITCH

The base element of a knit fabric, "stitch" is used to describe the loop that sits on the needle while you're working and each individual loop in the fabric. (Fig. S12)

STITCH GAUGE

Your horizontal gauge—typically measured as the number of stitches in 4" (10 cm). See also *gauge*.

STITCH HOLDER

Something to reserve stitches and keep them live when you're not working on them. Safety-pin-style holders are better for a small number of stitches. (Fig. S13) If you need to put a larger number of stitches on hold, a length of scrap yarn threaded through the live stitches works best. Cable needles are sometimes referred to as cable-stitch holders. They're different tools for different purposes. See also, *cable needles; slip stitches to a holder*.

STITCH MARKER

See *marker*.

ST(S)

Stitch(es).

ST ST

Stockinette stitch.

STEEK

A column of stitches worked with the intention of cutting them, usually to create openings for necklines or armholes or to turn a pullover into a cardigan. In many knitting traditions, garments—particularly stranded-colorwork patterns—are worked as a tube in the round with steeks. This is done because it's easier to work stranded colorwork in the round rather than in rows.

STOCKINETTE STITCH, STOCKING STITCH

Basic knit fabric created by knitting all stitches on the right side and purling all stitches on the wrong side or knitting all stitches if working in the round. (Fig. S14) The back side of

Fig. S14 stockinette stitch, one row highlighted

Fig. S15 stranding guide

stockinette stitch is called reverse stockinette stitch in patterns where it is on the right side. The fabric doesn't lie flat, it tends to roll up. See also *reverse stockinette stitch*.

STRANDED COLORWORK, STRANDING

Knitted fabric created by working two colors in a row or round, creating patterns by alternating the colors. Stranded-colorwork patterns, also known as Fair Isle, feature frequent color changes in a row, usually with no more than five to seven stitches in one color before changing to the other. The classic pattern motifs often have strong diagonal lines, forming cross or diamond shapes. These details help a knitter manage tension and keep the fabric as even as possible.

See also *colorwork; Fair Isle*.

STRANDING GUIDE

A small thimble-like tool used for working stranded colorwork that keeps two strands

of yarn separate and anchored so they don't change position. Stranding guides are typically used by Continental knitters so that they can hold both yarns in the left hand and more easily "pick" them. (Fig. S15)

SUPER-BULKY (YARN)

See *yarn attributes, weights*.

SUPERWASH WOOL (FIBER/YARN)

Derived from the coat of sheep. It the same fiber as standard wool, but treated so it is resistant to felting and therefore machine-wash safe. Although you still need to take care; a hot or vigorous wash can still cause damage. It is inclined to stretch, particularly if worked at a loose gauge. It's better for garments with seams, rather than seamless. See also *fiber care; wool*.

SWATCH

A small patch of fabric, knitted as a test piece to measure gauge and test out the yarn. See also *gauge*.

SWEATER ANATOMY

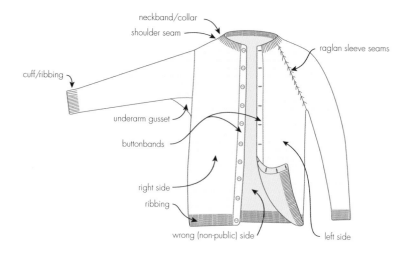

neckband/collar
shoulder seam
raglan sleeve seams
cuff/ribbing
underarm gusset
buttonbands
right side
ribbing
wrong (non-public) side
left side

SWEATER CONSTRUCTION

Garments can be worked with seams or seamlessly.

seamless/one-piece garments

Raglan and circular yoke sweaters are typically worked seamlessly—that is, in a single piece, without having to do any seaming.

You can make cardigans or pullovers this way. Pullovers are worked entirely in the round. The body of a cardigan is worked flat, but the sleeves are usually worked in the round. They can be worked top down, from the neck to the hem, or from lower hem up to neck.

There are patterns for other styles of garments, too—the "contiguous" set-in sleeve construction is becoming more common— although they are more challenging to design and knit.

Seamless garments are popular for two reasons. The calculations for the raglan and circular-yoke versions are straightforward, and well-documented, and a lot of knitters don't feel confident about seaming. It's a great way to work kids' garments and traditional colorwork sweaters, particularly those in lighter yarns (lopi fits the bill here, alapaca or cotton would absolutely not). An adult-size sweater is heavy and without the stabilization of seams will stretch out over time and get saggy.

seamed garments

Working a garment in pieces that are sewn together provides more flexibility of shape and therefore fit and style. Seams also have a structural benefit: they don't stretch and therefore provide important structure and support for knit fabrics. Garments, especially adult sizes, can be pretty heavy; when worn

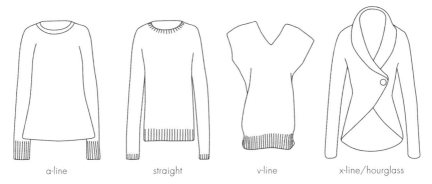

| a-line | straight | v-line | x-line/hourglass |

Fig. S16 sweater silhouettes

even slightly loose, they hang off the body. Without structure and support, they will sag and droop and stretch out.

If you want a truly flattering garment that fits well, looks tailored, and holds it shape over time, you'll get much better results with a seamed garment.

SWEATER SILHOUETTES

Silhouette is defined by how a garment hangs from the underarm—the body shape. (Fig. S16)

a-line silhouette

This garment shape is narrow at the bust and widens toward the hem, giving the appearance of the letter A.

straight silhouette

Garments knit without any waist shaping are said to have a "straight" silhouette. These measure the same circumference at the bust and at the hem.

v-line silhouette

Made to accentuate the shoulders, V-line garments start very wide at the top—usually with a deep V-neckline—and taper in at the waist.

x-line/hourglass silhouette

The hourglass silhouette features a wide bust and hem with a tapered, narrow waist.

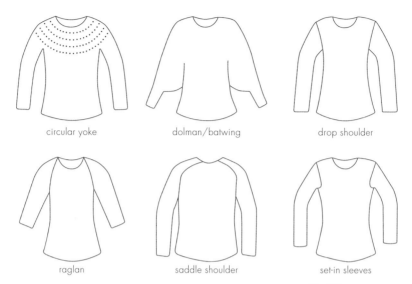

circular yoke dolman/batwing drop shoulder

raglan saddle shoulder set-in sleeves

Fig. S17 sweater types

SWEATER TYPES

When knitting sweaters, the "type" of sweater you're knitting is often referenced by a particular feature the garment has when compared to others. (Fig. S17)

circular yoke

Worked seamlessly in the round, sometimes from the neck down, sometimes from the hem up. Many types of stranded-colorwork sweaters are worked this way.

The design was very popular in the 1980s and is often worn oversized. It's actually more flattering—and on a surprising range of body types—when worn close-fitting.

dolman/batwing

A loose and drapey sleeve style. Batwings are a more exaggerated version of a dolman sleeve. The more exaggerated the dolman—the lower the sleeve/body seam—the more ease is required. Modern dolmans are less exaggerated, with slim-fitted sleeves that start around the elbow. Can be worked seamless or in pieces and seamed. The batwing is a more exaggerated version of a dolman.

drop shoulder, modified drop shoulder

A simply constructed garment, with little or no shaping for armholes, sleeve tops, and shoulders. It is worn loose, and the look is relaxed and casual. Most often worked in pieces.

raglan

A popular sweater type that denotes four diagonal lines dividing the arms from the body. Most raglans are worked seamlessly in the round, sometimes from the neck down, sometimes from the hem up. Some

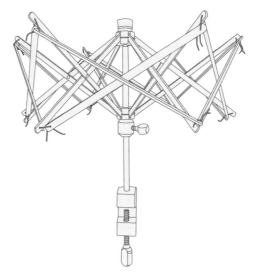

Fig. S18 *swift*

patterns for raglans involve working the pieces separately and seaming.

The raglan works on all body types as a relaxed, casual garment. When worn more fitted, it's flattering to significantly fewer.

saddle shoulder

A saddle shoulder is a variant of a set-in sleeve or raglan. The sleeve has a narrow extension from the top of the cap that fits between the front and back along the shoulder seam. The front and backs are a little shorter to compensate for this extra piece.

set-in sleeve

A classic, tailored style of garment. Most often worked in pieces and seamed. Patterns for seamless versions do exist, but these are generally more complicated to work.

Of all the styles, it looks best when worn close-fitting, since it mimics the lines of the body—but it doesn't need to be worn fitted. Although, if the garment is to be worn with significant positive ease, a less-shaped style such as a drop shoulder would work just as well!

SWEETHEART NECKLINE

See *necklines and collars*.

SWIFT

A tool to hold a skein of yarn while it's being wound into a ball; most often used with a ball winder. The umbrella-style swift is common, so called because it collapses down much like an umbrella for storage. (Fig. S18) See also *ball winder*.

TAIL

The end of yarn connected to the first stitch cast on or the last stitch bound off. You should make sure your tail is at least 3" (7.5 cm) long. Any shorter and it will be difficult to weave in.

TAM

See *hat styles.*

TAPESTRY NEEDLE

See *yarn needle.*

TASSEL

A gathering of yarn pieces, tied together, and used for decoration.

TECHNIQUE

Using a piece of cardboard the length you want your finished tassle, wrap the cardboard several dozen times with yarn. Tie the yarn ends using an overhand knot along the narrow end of the cardboard. Cut the wrapped yarn and the narrow end opposite the overhand knot to release the yarn.

While grasping the cut ends of the tassel, tightly wrap the tassel near the overhand knot with additional yarn. Tie the tail ends of the wrapping yarn with another overhand knot and use a yarn needle to weave the ends into the tassel. (Fig T1)

TBL

Through the back loop. See also *ktbl; ptbl.*

TENCEL (FIBER/YARN)

Highly processed fiber derived from plants. The process is slightly different from rayon, but produces similar results. See also *rayon; fiber care.*

TENSION

In the United Kingdom the term for gauge, "tension" also is used when talking about how tightly or loosely yarn is held and stitches are worked. See also *gauge.*

THREE-NEEDLE BIND-OFF

A bind-off method that involves knitting together two edges of live stitches.

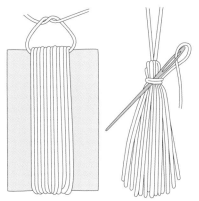

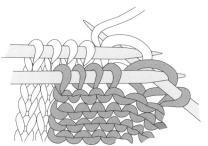

Fig. T1 tassel

Fig. T2 three-needle bind-off

TECHNIQUE

Place stitches to be joined onto two separate needles. Hold them with right sides of the pieces together. Insert a third needle into first stitch on each of the other two needles and knit them together as 1 stitch. *Knit next stitch on each needle the same way. Pass first stitch over second stitch. Repeat from * until 1 stitch remains on third needle. Cut yarn and pull tail through last stitch. (Fig. T2)

TINK

To undo your knitting, stitch by stitch. It's "knit" spelled backward. See also *frog*

TOE-UP

One of the two most common constructions for socks, this method has you cast on at the toe and work up toward the cuff. See also *sock anatomy*.

TOG

Together.

TOP-DOWN

One of the two most common constructions for socks, this method has you cast on at the top of the leg and work down toward the toe. Garments can also be made top-down, generally seamlessly, in one piece. Stitches are cast on for the neck, and the body worked down from there. See also *sock anatomy; sweater construction*.

TOQUE

See *hat styles.*

TURTLENECK

See *necklines and collars.*

T-PIN

See *blocking tools.*

TWEED

See *yarn attributes, color.*

Fig. T3 twisted ribbing

TWISTED RIBBING

Any ribbing pattern where stitches are worked through the back loop (tbl). The most common versions are based on (k1, p1), and only the knit stitches are twisted. (Fig. T3) See also *ribbing.*

TWO-HANDED STRANDING

A way of working stranded colorwork, holding one yarn in each hand. See also *colorwork, color knitting; stranded colorwork, stranding.*

U-NECK
See *necklines and collars.*

UFO
Unfinished object. This acronym is commonly used in reference to an incomplete project that you're not currently working on. It can convey a sense of abandonment, often to describe a project you fear you might never finish or you've simply given up on. See also *WIP; FO.*

UNDYED
See *yarn attributes, color.*

UNKNIT
To undo your work, stitch by stitch, using your needles. It's a slow but careful way of undoing your work. Sometimes called "tink," which is "knit" spelled backward. See also *frog; tink.*

UNRAVEL
To undo your knitting. Take the needle out of the live stitches and tug on the yarn to undo the fabric. This is an extreme measure and is only advised if you wish to undo the whole thing (or a very large section), as it can be difficult to pick up and restore the stitches. Tinking is safer if you only want to do undo a few stitches or rows. See also *frog; tink.*

VARIEGATED

See *yarn attributes, color.*

VICUÑA (FIBER/YARN)

Derived from the coat of the Vicuña, a small
and rare member of the alpaca family. It is
ridiculously soft and warm, but also heavy
and inclined to stretch. It is difficult to gather,
therefore it is very expensive. Look for it in
blends to add softness and warmth. See also
fiber care.

VISCOSE (FIBER/YARN)

Highly processed fiber derived from plants.
Sometimes used as a synonym for rayon, since
it is also the term for the process by which
rayon is created. See also *rayon; fiber care.*

V-NECK

See *necklines and collars.*

W&T

Wrap and turn; a technique for closing up the gap in short-rows. There are variations on how to work this. The simplest method is to slip the next stitch to the right needle, take yarn to opposite side of work between needles, slip same stitch back onto left needle. Turn work, ready to begin working in opposite direction.

If you're working in stockinette stitch, the wraps will be visible on the right side of the fabric. (They hide nicely in garter stitch and on the purl side of stockinette stitch.) To "hide" the wraps, on the next row lift the wrap and work it together with the stitch. See also *short-rows*.

WASTE YARN

Appears in patterns when it's instructing to place stitches on hold. Any yarn can be waste or scrap yarn, though. When moving stitching to a holder, cotton works best.

WATCH-CAP

See *hat styles*.

WEAVING IN ENDS

To tidy up and secure the ends of a piece by threading them into the knit fabric. If the yarn is fuzzy, sticky, or feltable (a rough wool), you can be a bit more casual about the process, as this type of yarn is less likely to unravel. If the yarn is smooth or slippery (a finer wool, silk) or doesn't have any felting ability (superwash wool or cotton), then you need to be more careful.

In general, you want to weave in about 3 to 4" (7.5 to 10 cm) of yarn and weave in a couple of different directions. There is great debate

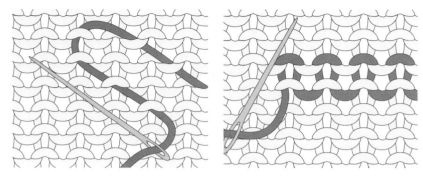

Fig. W1 two methods for weaving in ends: diagonal (left) and duplicate (right)

about this, but I prefer to weave in ends after blocking. If the fabric stretches or shifts with blocking, a previously woven-in end can create a pucker.

The best place to weave in an end is on a seam, since it will never be visible. If you don't have a seam, try to find a place that's a bit hidden—the back of the leg for a sock, for a garment, under the arm, or on the underside of a sleeve. (Fig. W1)

WEIGHT

Used casually when describing yarn, to mean thickness. See also *yarn attributes, weights.*

WELT

A horizontal form of ribbing that can be achieved a few ways. The easiest way to work a welt is to knit a few rows of stockinette stitch, followed by a few rows of reverse stockinette stitch, followed by more stockinette stitch.

A stockinette-stitch welt can be worked by knitting the first stitch on the live needle together with the bar stitch three to four rows below from the back side.

WHIPSTITCH

A sewing method. It's not well suited for seaming, but is helpful for sewing down the edge of a hem or securing a turned-over neckline or collar. To whipstitch two edges together, catch strands on both edges, going from the front through to the back. See also *seaming.*

WIP

Work in progress. See also *FO; UFO.*

WOOL (FIBER/YARN)

Derived from the coat of sheep. Very warm, insulating, and breathable. It wicks away moisture and has elasticity when wet, so it can be blocked for lace and colorwork, but it's stable when it's dry. Suitable for all applications. If budget is a concern, wool is excellent blended with other fibers. See also *fiber care.*

WOOL WASH

A gentle, fiber-friendly soak that cleans knit items without needing to be rinsed out of the fabric. See also *fiber care.*

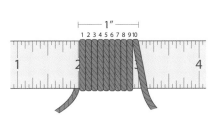

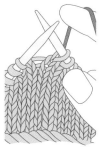

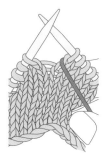

Fig. W2 WPI **Fig. W3** WYIB **Fig. W4** WYIF

WORKING YARN

The yarn you're actually knitting with, attached to the active ball of yarn.

WPI

Wraps per inch. In spinning, this is used as a guide to yarn thickness. Yarn is wrapped around a ruler so that the surface is entirely covered, but the threads are not pressed together. The number of times the yarn is wrapped around an inch is counted. (Fig. W2)

WS, WRONG SIDE

The hidden, inside, or secondary side of your knitting. Sometimes referred to as the "private" side of your work. See also *RS, right side; right side.*

WYIB

With yarn in back. (Fig. W3) Part of an instruction to slip a stitch, indicating where the working yarn should be positioned. See also *slip-stitch knitting.*

WYIF

With yarn in front. (Fig. W4) Part of an instruction to slip a stitch, indicating where the working yarn should be positioned. See also *slip-stitch knitting.*

YAK (FIBER/YARN)

Derived from the coat of a yak. It is similar to wool, but warmer, softer, and more expensive. Excellent on its own or in blends for garments and accessories. See also *fiber care*.

YARD

A unit of measurement, equal to 36" (.91 m). Often used for indicating the length of a ball or skein of yarn. See also *metric conversions*.

YARN

Thread for knitting with. It's typically referred to either by color, texture, or weight.

YARN ATTRIBUTES, COLOR

Common terms used to describe yarn colors.

TERM	DEFINITION
"FAUX ISLE"	The yarn has very short stretches of color that result in a Fair Isle–like effect in the knit fabric.
GRADIENT	A yarn that changes color slowly, with large patches of a solid color and a gradual blending shifting to another color.
HAND-DYED	This describes the process by which the yarn is dyed and doesn't really say anything specific about the coloring of the yarn.

TERM	DEFINITION
KETTLE-DYED	Although mostly describing the process by which the yarn is dyed, this term is often used to describe a semisolid yarn.
MARLED	Describes two or more different colors of yarn plied (twisted) together. The individual color strands themselves may be a solid color, or they may be variegated in some way.
NATURAL	This is used to mean one of two things: either that the fiber is undyed or that it has been dyed with a "natural" (most commonly plant-based) dye.
SELF-STRIPING	Yarn is dyed so that it stripes when knitted up. Most self-striping yarns produce a slightly "disorganized" effect, with unpredictable color changes. Some yarns are dyed to create fixed, predictable stripes, but this process is more complicated. Yarns that do this will clearly indicate so on the label.
SEMISOLID	The yarn that is a single color, but has tonal variations throughout (some sections darker, some sections lighter).

TERM	DEFINITION
SOLID	Yarn is a single, even color throughout.
SPECKLED	The dyer has applied drops of dye to create dots, or speckles. You'll often see this on a semisolid background, and the speckles create a mottled look.
TWEED	A solid or near-solid yarn with specks of contrasting color fiber spun in to create flecks of color in the resulting fabric.
UNDYED	No dye has been applied. It might not be a solid color, as fibers are very rarely a single solid color. (Think about human hair.) Some yarns deliberately blend together multiple different undyed colors for a tweed effect.
VARIEGATED	This is a general term, meaning that the yarn has color changes in some way.

YARN ATTRIBUTES, TEXTURES

	DEFINITION	TIPS ON USAGE
BOUCLÉ	Created from two or more strands, unevenly plied, so that one pulls away from the main strand, creating loops.	Garter stitch or reverse stockinette show off the texture best. Pill-resistant.
BRUSHED	A yarn with a "fuzzy" texture.	Good for many applications, although fine details of small-scale pattern stitches can disappear.
CHAINETTE	Not really a texture, but a way of making a yarn.	Well suited to all sorts of fabrics. Pill-resistant.
CHENILLE	Like a pipe cleaner: a core strand with short lengths of a fluffy thread spun into the cord to create fluffy tufts.	Best used for projects with plain fabrics or large-scale patterns such as ribbing and cables.
EYELASH	A solid strand of yarn with very short lengths of a finer thread spun into it. The ends of these finer threads extend from the core to create an "eyelash" effect.	Garter stitch.
FUZZY, FLUFFY	General term used to describe yarns that aren't smooth and have a "halo" of fiber around them. If you look closely, you'll see a central core, usually tightly twisted, with the fuzz extending out from that core.	Best used for projects with plain fabrics: any pattern stitches get lost in the texture.
NOVELTY	A broad category of yarns that have variable textures and often have decorative elements added—pom-poms, strands of fluff, bits of fabric, silk flowers, etc.	Usually best worked in garter stitch for scarves and wraps or decorative elements.
RIBBON	Narrow lengths of woven fabric, usually made out of a silk or man-made silk-like fiber, e.g., rayon.	Best worked in garter stitch.
SLUBBY	A yarn that varies in thickness along its length. Usually these are singles, with a deliberately applied inconsistent twist/spin: the tighter the twist, the finer the yarn; the looser the twist, the thicker the yarn.	Best used for projects with plain fabrics; can be fairly pilly.
SMOOTH	A yarn with consistent twist and thickness throughout.	Well suited to all sorts of fabrics. Pill-resistant.

YARN ATTRIBUTES, WEIGHTS

CATEGORY NAME	INT'L STANDARD NUMBER	TYPICAL GAUGE over 4 in/10 cm in stockinette stitch	TYPICAL NEEDLES	OTHER NAMES
THREAD COBWEB LACE LIGHT FINGERING	**0** LACE	n/a 32–34 sts	Depends on use; usually US #0–6/2–4 mm US #0–1.5/2–2.5 mm	1-ply, 2-ply, 3-ply
FINGERING	**1** SUPER FINE	28–30 sts	US #1.5–2.5/2.5–3 mm	4-ply, 14 WPI
SPORT/ BABY	**2** FINE	24–26 sts	US #3–5/3.25–3.75 mm	5-ply, 12 WPI
DK	**3** LIGHT	22 sts	US #6/4mm	8-ply, 11 WPI
WORSTED ARAN CHUNKY	**4** MEDIUM	20 sts 18 sts 16 sts 14–15 sts	US #7–8/4.5–5 mm US #6–8/4–5 mm US #10/6 mm US #10–11/6–8 mm	10-ply, 9 WPI 10-ply, 8 WPI 12-ply, 7 WPI
BULKY	**5** BULKY	12–14	US #11–15/8–10 mm	
SUPER BULKY POLAR	**6** SUPER BULKY	8–12 sts 6–8 sts	US #15–19/10–15 mm US #17–36/12.75–20 mm	5 WPI
JUMBO	**7** JUMBO	4–6 sts	US #17–50/12.75–25 mm	

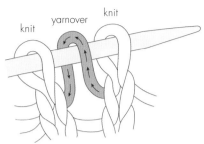

Fig. Y2 yarnover

Fig. Y1 yarn needles

YARN BARF

A term coined to describe the tangle of yarn that sometimes emerges when you pull out the end of a center-pull ball.

YARN NEEDLE

A blunt-tipped needle with a large eye for fitting yarn through. (Fig. Y1) Used for weaving in ends and seaming knit pieces by hand. Sometimes referred to as a tapestry needle.

YARNOVER

To bring the yarn over the needle to create a new stitch; to create a deliberate hole in knitted fabric. Often used in lace or openwork for a decorative effect. (Fig. Y2)

How you work a yarnover depends on the stitches before and after and how you hold your yarn.

The yarnover is strictly the "drape," the following stitch is not included or counted in the yarnover instruction. On the following row/round, you might knit or purl into the yarnover, the instructions will make that clear.

between knit stitches

Bring the yarn to the front, between the needles, into purl position. When you work the next stitch, let the yarn drape over the right needle to create the yarnover.

after a purl, before a knit

The yarn will already be at the front, just leave it there and let it drape over the right needle to create the yarnover.

after a knit, before a purl

Bring the yarn to the front, between the needles, into purl position, then take it over the top of the right needle, from the front to the back and around to purl position again.

between purl stitches

The yarn will already be at the front, take it over the top of the right needle, from the front to the back and around to purl position again.

multiple yarnovers

If you're asked to do a double or a triple yarnover—or even more wraps—work the first one and then continue wrapping the yarn over the needle in the same direction until you

have the number of wraps you need. On the following row/round, you may be told to work more than once into the multiple yarnover. It's basically impossible to knit more than once into a yarnover, so you will alternate knits and purls, or knits and knitting through the back loop, for example, working (k1, p1) into a double yarnover, working (k1, p1, k1) into a triple.

See also *increases*.

YARNOVER BIND-OFF
See *Jeny's surprisingly stretchy bind-off*.

YB
"Yarn back" or "yarn to back." Most often used in the context of an instruction to slip a stitch, this tells you where to hold the working yarn. Position is relative to the work on the needles, not the fabric (that is, not WS/RS). If you're told to move the yarn to the back, you're just moving it as if you were transitioning between purl and knit stitches.

YD
Yard, yards. See *metric conversions*.

YF
"Yarn front" or "yarn to front." Most often used in the context of an instruction to slip a stitch, this tells you where to hold the working yarn. Position is relative to the work on the needles, not the fabric (that is, not WS/RS). If you're told to move the yarn to the front, you're just moving it as if you were transitioning between knit and purl stitches.

YO
Yarnover.

YOKE
The upper section of a garment, between the armholes and the neck. You usually see this in the context of a seamless garment, describing the section where the upper part of the body and the sleeves are worked together, in one piece. See also *sweater types*.

ZERO 0

Used in pattern repeat instructions to indicate an instruction isn't to be worked.

EXAMPLE

Repeat the last 2 rows 0 (1, 2) more time(s).

For the smallest size, no repeats are worked.

You might also see, in a section of increases or decreases in a multisize pattern, an instruction to work something every 0 rows.

EXAMPLE

Work an increase row every 6 (4, 2, 0) rows, (1, 2, 3, 0) more time(s).

Z-TWIST

When the direction of twist is to the right in spun and plied yarns, it's called Z-twist. Z-twist yarn is the standard twist.

4

REFERENCES
AND
FURTHER
READING

GENERAL KNITTING

For general knitting help, I recommend *Vogue Knitting: The Ultimate Knitting Book* (Sixth & Spring Books, 2018) and Montse Stanley's *Reader's Digest Knitter's Handbook* (Reader's Digest, 1999). Stephanie Pearl Mcphee's *Knitting Rules* (Storey Publishing, 2006) shares a lifetime's worth of knitting lessons and expertise, in a very readable and encouraging manner.

If you wish to dig further, June Hemmons Hiatt's *Principles of Knitting* (Touchstone Books, 2012) is absurdly and gratifyingly encyclopedic, if slightly less approachable.

YARN

For more about yarns and fibers, I recommend Clara Parkes's two wonderful volumes, *The Knitter's Book of Yarn* (Potter Craft, 2007) and *The Knitter's Book of Wool* (Potter Craft, 2009).

Jillian Moreno's *Yarnitecture: A Knitter's Guide to Spinning* (Storey Publishing, 2016) talks about yarn from the perspective of the spinner.

If you want to dig really deep into fiber, you can't go wrong with *The Fleece and Fiber Sourcebook* (Carol Ekarius and Deb Robson; Storey Publishing, 2011).

READING PATTERNS

To learn more about the language of patterns and how patterns are written, look at my own book *Beginner's Guide to Writing Knitting Patterns* (Interweave/F&W, 2016).

KNITTING METHODS

For more about combination knitting, seek out Annie Modesitt's *Confessions of a Knitting Heretic* (ModeKnit Press, 2004). For more about Portuguese knitting, find Andrea Wong's *Portuguese Style of Knitting History, Traditions and Techniques* (Andrea Wong Knits, 2010).

GARMENTS

Amy Herzog's *You Can Knit That* (Abrams, 2016) is a fantastic introduction to garment styles, sizing, and fit. To dig further into style and fit, Maggie Righetti's *Sweater Design in Plain English* (St. Martin's Griffin, 2011) is a great read, even if you're not looking to design anything.

For more about garments, *Fashionpedia:The Visual Dictionary of Fashion Design* (Fashionary, 2016) is a fabulous resource.

METRIC CONVERSION CHART

TO CONVERT	TO	MULTIPLY BY
Inches	Centimeters	2.54
Centimeters	Inches	0.4
Feet	Centimeters	30.5
Centimeters	Feet	0.03
Yards	Meters	0.9
Meters	Yards	1.1

ACKNOWLEDGMENTS

Many thanks to all who helped this thing make its journey from wild-eyed ill-formed idea to well-organized, beautifully illustrated reality.

To those who answered strange questions over email or who watched me gesture madly during Skype calls: Cari Angold, Fiona Ellis, Amy Herzog, Kim McBrien Evans, Jillian Moreno, and Lynne Sosnowski.

At Interweave/F&W: Special thanks to Kerry Bogert, who understood my idea and fought for it, and to Maya Elson for helping me make sense of it all. And to Julie Levesque for a beautiful book design and illustrations.

And to Norman, who kept making more coffee.

DEDICATION

For my parents, who never refused me a book.

ABOUT THE AUTHOR

Kate Atherley is a mathematician and escapee from the technology industry. She has written three other books for Interweave—*Knit Mitts, Custom Socks,* and *The Beginners Guide to Writing Knitting Patterns.* She is Knitty's lead technical editor and a regular contributor to books and magazines. She lives in Toronto with her husband and their challenging, but mostly adorable, rescue hound, Dexter.

MORE GREAT KNITTING RESOURCES FROM KATE ATHERLEY!

CUSTOM SOCKS
Knit to Fit Your Feet

9781620337776

$27.99

THE BEGINNER'S GUIDE TO WRITING KNITTING PATTERNS
Learn to Write Patterns Others Can Knit

9781632504340

$27.99

KNIT MITTS
Your Hand-y Guide to Knitting Mittens & Gloves

97816325047920

$23.99